the art
and
technique
of
SUMI-E

the art and technique

Japanese
ink-painting
as taught by
Ukai Uchiyama

by
Kay Morrissey Thompson

of Sumi-e

CHARLES E. TUTTLE COMPANY: Rutland, Vermont: Tokyo, Japan

Published by Tuttle Publishing Co., Inc., an imprint of Periplus Editions, with editorial offices at
153 Milk Street, Boston, MA 02109, and 130 Joo Seng Road, #06-01/03, Singapore 368357

LCC Card No. 60-10951
ISBN 0-8048-1959-9

First edition, 1960
First paperback edition, 1994
Fifth printing, 2004

Distributed by:

Japan **Tuttle Publishing**, Yaekari Bldg, 3F, 5-4-12 Osaki, Shinagawa-ku, Tokyo 141-0032. Tel: (03) 5437 0171;
Fax: (03) 5437 0755; Email: tuttle-sales@gol.com
North America, Latin America & Europe **Tuttle Publishing**, 364 Innovation Drive, North Clarendon, VT 05759-9436.
Tel: (802) 773 8930; Fax: (802) 773 6993; Email: info@tuttlepublishing.com. Website: www.tuttlepublishing.com
Asia-Pacific **Berkeley Books (Pte) Ltd**., 130 Joo Seng Road, #06-01/03 Singapore 368357.
Tel: (65) 6280 1330; Fax: (65) 6280 6290; Email: inquiries@periplus.com.sg

Printed in Singapore

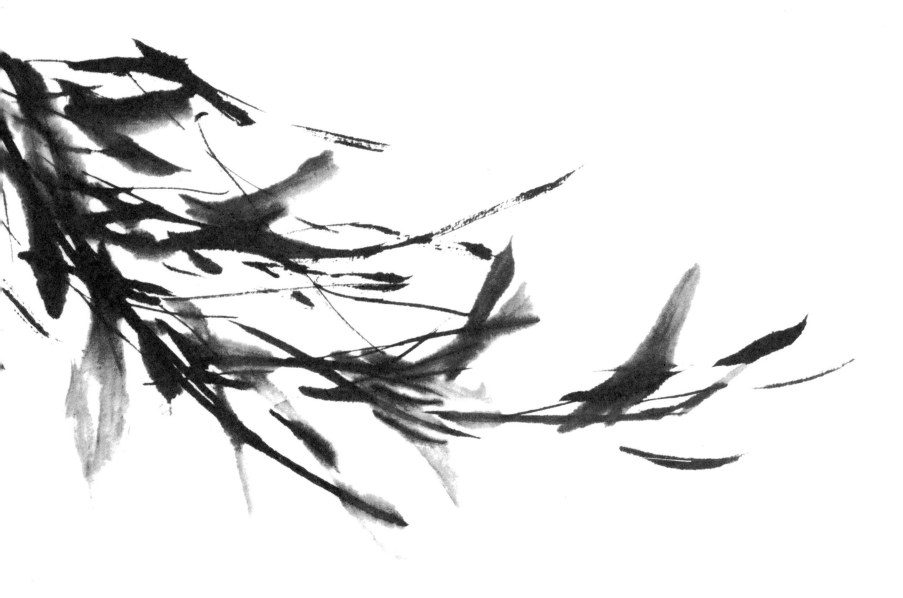

table of contents

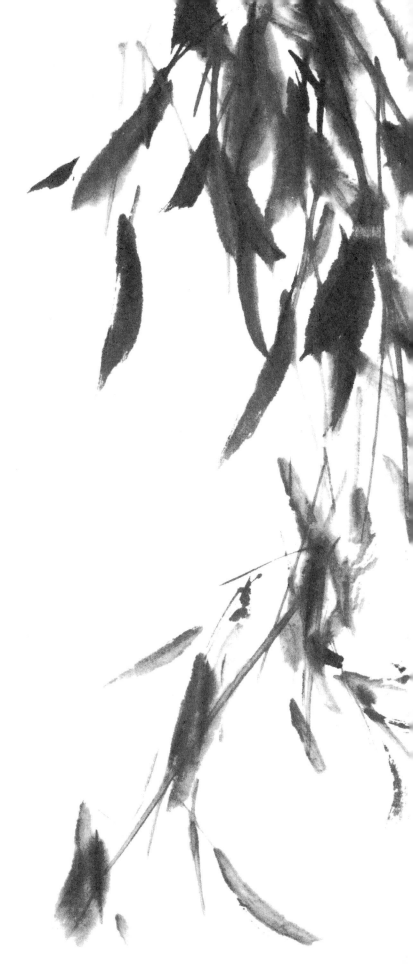

an introduction to Ukai Uchiyama,

An ardent gallery-goer in Tokyo may be surprised to find wall after wall covered with brilliant abstractions in oil pigments on canvas. Many Japanese artists are experimenting with this more lavish medium which does permit of greater freedom of technique and subject matter—or lack of subject matter. Oil painting in Japan is a relatively new challenge after centuries of the rigid discipline of monochrome painting. There seem to be no rules or restrictions in applying oil to canvas excepting the artist's own, and many of today's artists are enthusiastically enjoying this new freedom.

Even so, the ancient art of *sumi-e,* or Japanese ink-painting, though now somewhat in eclipse, has not disappeared from the contemporary scene. To a Westerner who feels sometimes saturated with rampant color, these linear and calligraphic interpretations stand out even monochromatically as the most colorful of all. One wonders what it is that makes this art still thrive though centuries of artists have come and gone, though other styles and schools of thought have had their days of great popularity only to give way to new and different ones. The art of sumi-e has remained essentially the same, varying only according to the skill and imagination of successive artists. For although there are rules to this art, they serve to stimulate rather than to arrest artistic creativity. Following the old techniques without feeling or imagination can perhaps lead to superficial skills, but more than this is required of the *sumi* artist.

In ancient China, mastery of brush and ink was the accomplishment of scholars who were at once poets, philosophers, and often Buddhist priests, as well as painters. Similar brushes were used for both writing and painting and the two arts invariably shared the same piece of silk or paper. Indeed, the written characters themselves evolved from visual symbols, gradually becoming more and more abstract and losing much of their pictorial quality. It is further evidence of the affinity of the two arts that the strokes used for calligraphy frequently are adopted by the sumi artist to represent, say, the branch of a tree or the tail of a bird. If calligraphy is writing, sumi-e is the painter's language of nature, with various techniques forming his vocabulary.

When Buddhist priests brought the ink stick and bamboo-handled brush to Japan in the sixth century, the Japanese soon became adept in their use and for the past fourteen centuries have been contributing to their own heritage of ink painting. The artistic accomplishments of successive Japanese artists are to be admired in books, museums, and reproductions, but the techniques themselves have been passed from generation to generation by means of personal instruction and apprenticeship. As a result, not enough information is available to the inquisitive Western artist who is attracted to this art.

It is for this reason that, through my dear friend Mrs. Tadako Arakawa, I sought and found Mr. Ukai Uchi-yama, master calligraphist and artist, a contemporary inheritor of the long and honorable line of Japanese sumi artists. (His art name, Ukai, seen both in the last two characters of his signature at the left and in his seal at the upper right, means "Rainy Sea.") Like his artistic ancestors, he is a philosopher, calligraphist, scholar, and teacher. He continues the tradition of teaching along with his painting as is expected of those with superior gifts. In Japan the *sensei*—master or teacher—of any subject is one who commands great admiration and respect.

Uchiyama-sensei agreed to take time from his busy schedule to introduce me to his own contemporary calligraphic version of sumi techniques. After we had painted together two or three times I realized there must be many other artists, potential or accomplished, who might like to share this study. Mr. Uchiyama found the idea to his liking since he had received many requests for information from artists and interested persons from other parts of the world. From then on, we worked together to prepare this book, all without benefit of a mutual language other than that of the brush. Fortunately, Mr. Uchiyama's daughter, Mrs. Yuko Takenouchi, and his son, Ryuichiro Uchiyama, served as interpreters extraordinary, not only translating their father's instructions but also helping me interpret his thoughts. Some techniques and strokes needed little or no translation since just watching Sensei execute a masterful stroke with the brush and watching the wet, black sumi flow swiftly and beautifully into a creation of great excitement was beyond any spoken or written language. But how to put into words this magic one has witnessed? Perhaps it is not possible to translate the language of painting into the language of words. Certainly words alone cannot make an artist. In the end it is only the artist himself who, through application and effort, observation and development, can attain his maximum fulfillment. But words may attempt to direct and suggest, perhaps even inspire.

All the words used here are my own, but based directly upon Mr. Uchiyama's teachings. All the drawings are by him, some drawn for my lessons and some prepared especially for this book. They speak for themselves much more eloquently than I ever could.

In Japan painting is not restricted exclusively to the career artist. It is a creative expression happily pursued by countless numbers of people of all ages and capabilities who constantly travel miles to view seasonal blossoms or honored mountains. It is the desire to record these experiences of beauty, regardless of the individual's degree of talent, which prompts this creative activity. While the world always seeks great masterpieces, there is also a satisfying joy in every modest attempt.

It is my hope that this mutual effort of East and West will reach those who desire to understand some of the underlying philosophies and contemporary techniques of this old yet ever new form of painting.

master calligraphist and sumi painter

at ease

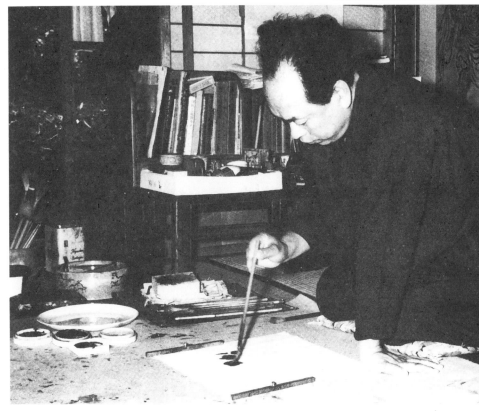

at work

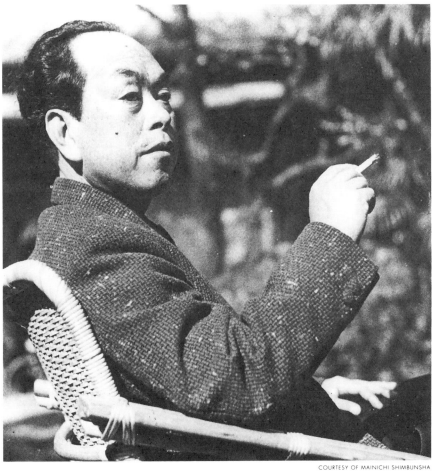

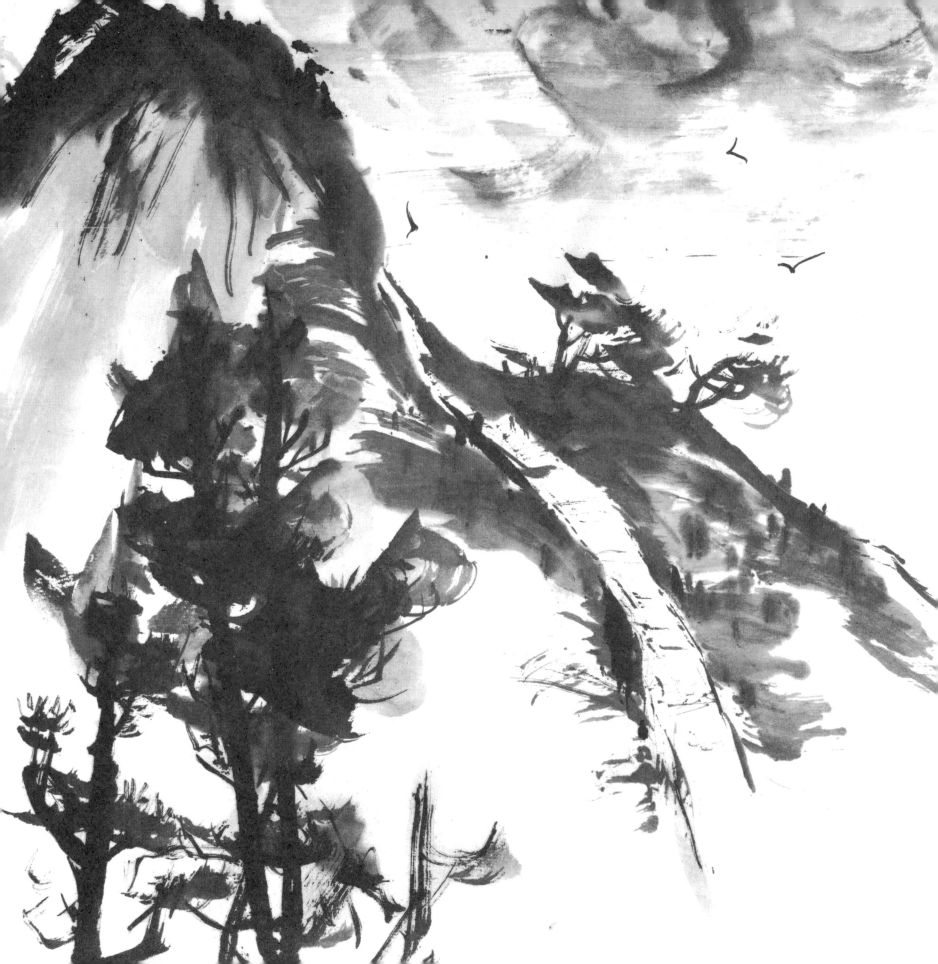

The *sumi* artist is so named because of the materials he uses. Sumi itself is a compressed cake of fine black soot made from the burning of certain vegetable oils, bonded with a pure animal gelatin, and molded into a convenient stick form. The sumi stick, rubbed gently in a little water, becomes the rich, black ink so essential to the creation of sumi-e. The best formulas for the making of sumi have been carefully guarded secrets, handed down for centuries in China and Japan. Many of these formulas, unfortunately, have been lost with their makers. Some of the finest sumi being made today still comes from China, or from Nara, in Japan, where a group of manufacturers continues a tradition of sumi-making which began centuries ago. Of the many grades and qualities of sumi, that most highly desired for painting is called *seiboku,* which has a slight blue cast to its blackness. *Kokuboku,* a pure-black sumi, is acceptable, while *shiboku,* with a slight purple tone, and *chaboku,* a brownish sumi, are adequate. As in any other art, the use of the best available materials is of utmost importance.

The paper used for sumi-e is a superior grade, especially soft and absorbent handmade paper from China or Japan, often referred to as "rice" paper but actually made of various other vegetable fibers. It is made in large sheets, approximately 27 by 54 inches. Due to its thinness, it has a tendency to wrinkle after it has been painted on, so that it must be mounted and stretched after it is dry. This skilled process is called *ura-uchi* and is essentially the same as that used in the making of folding screens and *kakemono,* or hanging scrolls. There are, however, papers already mounted, called *shikishi,* which are available in a variety of sizes; these do not wrinkle and therefore are easier to handle. For brush-stroke practice, there are heavier, less expensive "rice" papers suitable to the purpose, or even old newspapers may be used for rougher practice. The fact that the paper must be soft and absorbent, however, is very important in any finished work. This quality is essential in order that the wet sumi may spread and blur when the artist so desires, thereby properly playing its role in close counterpart to the sumi.

The sumi stick is rendered into a liquid by blending it with a little water on a stone slab which slopes gently to a small depression at one end. This dish is called a *suzuri.* The stone is of a fine texture, hard but smooth. A small amount of water is poured into the indentation and the sumi stick is rubbed gently back and forth on the surface of the stone, now and then being dipped into the water. Gradually, the water becomes a rich, black mixture ready for use. The process of blending should not be hurried and, depending upon the amount of ink to be made, may continue as long as twenty or thirty minutes—a valuable period of quiet, incidentally, during which the painter can prepare himself mentally for the work to come. When ready for use, the sumi mixture will have the consistency of rich cream and the surface sheen will be slightly dulled. Fresh sumi should be prepared prior to each painting session, and the suzuri carefully washed after each use.

When the sumi has been properly mixed, it is then the richest, most opaque black used in sumi-e. This darkest value is called *noboku,* "thick ink." For purposes of tonal gradation, two separate dishes are now needed. In one, noboku and water are combined to create a middle value called *chuboku,* "medium ink." The third and lightest value, called *tamboku,* "thin ink," is mostly water to which very little noboku has been added. These three values, in combination with the all-important white paper, are the only "colors" actually needed for sumi-e. The skill of the artist can make these tones suggest all the colors and values found in nature. It is part of the requisite simplicity of sumi-e that it not be complicated with too many indistinct values.

Other colors may sometimes be used, but only with restraint: perhaps one or two colors in addition to the gradations of black. Like sumi, the better color paints come in stick form and are rubbed into a little water to the proper consistency. The finer grades of water-color paints in either cake or tube, if more conveniently available, are also suitable.

When preparing to paint, the Japanese artist spreads a large felt-like cloth called *mosen* on the tatami floor. This thick, soft, woolen fabric serves as a resilient, nonsticking undersurface to the paper and also tends to repel excess moisture which may seep through the paper, thus keeping the moisture in the paper and making it possible for the artist to achieve the degree of blurring he may desire in a painting. The artist's materials are placed on the mosen in a logical order of use, and he kneels and sits on his heels on a *zabuton,* or cushion. As he paints, he leans over his work and freely uses his whole arm and shoulder in executing his brush strokes. Since the Western artist is not accustomed to this painting position, it is suggested that the mosen (a heavy felt would do as well) be spread on the surface of a large table and the artist work standing up. This will also permit the arm the freedom so necessary in sumi techniques. The working surface must be horizontal; hence the conventional easel is, of course, impracticable.

Sumi brushes, known as *fude,* have long handles made of bamboo. The bristles are also longer than in the average water-color brush and are circularly composed, tapering to a point. The bristles are chosen from a wide selection of hairs: goat, badger, horse tail, and softer ones of rabbit fur and even hair from an infant's first haircut! The soft-bristled brushes are generally used for very thin lines, such as a flower outline, since they taper to a finer point, while they are also used on their sides for the soft wash strokes interpreting petals or leaves. The coarser brushes are used for stronger linear techniques such as tree and branch strokes.

While these materials are unique in themselves, it is the manner in which they are used together that forms

what

makes

the

sumi artist

his materials,
his attitude,
his subjects,
his sketchbooks,
his techniques.

the most characteristic technique of sumi painting. The artist understands the important relationship of these materials and seeks to bring them together, enhancing the one with the other through the skill of his brush and the freedom of his imagination. Once the stroke is on the paper it can neither be redone, corrected, nor eliminated. If the brush is too wet, the sumi may spread too far; if too dry, it will not spread enough. Experimentation will reveal to each artist the degree of wetness of the brush appropriate to the stroke desired. It is this reaction of the sumi and brush to the paper, through the skill of the artist, which adds an exciting aspect to sumi painting. There will, nonetheless, be unexpected blurs and white areas where the brush eludes the paper, but these uncontrived happenings often add vitality and spontaneity to a painting.

In the fluid use of the brush, the Orientals have an inherent advantage over others, since from their earliest school years they have spent innumerable hours studying calligraphy, thereby acquiring the ability to handle the brush with assurance. Calligraphy and sumi painting are allied arts. The very word for both writing and painting is the same—*kaku*—and the Japanese artist says he is "writing a picture"! The materials used in both cases are quite similar, and the brush too is held in the same way, lightly but firmly, with the thumb and two or three fingers near the top. In calligraphy, a fine art in itself, the mark of the master lies in his ability to express himself with versatility, the delicacy or strength of his brush stroke expressing both the meaning of the words he is writing and his emotional reaction to them. The calligraphic artist is capable of many brush moods. There is a saying in Japan about calligraphy—*Izen hitsugo,* literally, "Mind before, brush after"—which means that one should have his work well in mind and be spiritually attuned to it before taking brush in hand. Feeling the mood behind the stroke of the brush in this way is equally important in sumi painting. An artist feels the strength of a jagged rock or a gnarled pine before beginning to paint and imparts this strength through his brush to his painting.

An artist's, or calligraphist's, own personality adds other individual qualities to his work. Brush strokes reveal character and temperament just as handwriting reveals much to those expert in that study. It is desirable for the sumi artist, as well as the calligraphist, to be free from excessive timidity in his work. A painting may be delicate and sensitive without being weak or indecisive.

In order to attain the desired control of the brush stroke, continued practice is the most rewarding contributory factor. At the same time, brush control can be greatly nourished through a study of the endless varieties of line and form in nature. There can be little doubt that nature is the best teacher of line and form, as well as of color, and the best of art begins there. For this reason, whenever possible, it is well to paint directly from nature's source—a flower, a branch, a tree, a fish, a mountain, or whatever one finds interesting. It is surprising how this direct study between eye and subject can impart life and vitality to the quality of a line. Looking at the

twist of a leaf will indicate to the artist the stroke of the brush best suited to portray that leaf. The human mind cannot invent the infinite variety of line that nature spreads before us. By painting directly from nature we acquire a familiarity with these lines and forms which cannot help but incorporate itself into our work.

More specific observation and study of nature's forms and lines may be gained through the sketchbook habit. Sumi painting is highly selective (unnecessary and uninteresting elements being rejected); but in order to be selective an artist must know much about the complete structure of what he is painting. This is self-acquired through constant observation and study, and recorded in an ever-growing series of sketchbooks. Since the very nature of the materials of sumi painting is such as to make it impractical to paint at the actual scene, the sumi artist may do much of his preparatory work in pencil or ink. This also helps in the process of selection since it is possible to train oneself to view a scene with the techniques of sumi-e in mind, omitting extraneous details. The sketches are not a mere copy of nature, but a creation from nature, attempting to achieve an even greater beauty. This does not imply that there should not be included in the sketchbook many drawings in accurate detail of the construction of a leaf or a flower, for this is necessary for the knowledge and understanding which allows the artist to paint more freely and to accentuate those qualities which give character to the subject. There is no limit to the variety of subject matter to be studied. It need not be limited to subjects usually associated with Oriental painting, but can expand to whatever local inspiration there may be. In this book, for example, there are those subjects that are alien to Japan, such as the rose and the pineapple. Whatever the subject, it can be sketched and painted from many aspects—in different seasons and stages of growth. Observations may be made of the same flower in the wind, the rain, in bud form, full blossom, and pod. Wisteria, for example, is beautiful in the spring when in full bloom, but equally interesting when it reaches that stage in the autumn when the flower has gone to seed. Nature in all its aspects affords endless variety in wealth of subject matter.

After completing each sketch, it helps for future reference if notations are added as to the name of the subject, the date, where and under what conditions it was sketched, and any other particular characteristics, such as color, which may be indicated and added to the sketch later. These sketches will aid the artist, either immediately or at a later date, in providing material for a sumi painting. They are both a storehouse of knowledge and inspiration, and also a satisfying expression in themselves.

In sketching, as well as in painting, there are other attributes of sumi-e that might well be kept in mind. The white paper is the only background in this form of painting. Unpainted areas may suggest sky, water, or simply remain a beautiful part of the composition. The bend of a branch becomes a few strokes of the brush caught flat against a white sky. An area of white left untouched between two mountains is a winding river or clouds of mist

Decorated sticks of sumi.

Mixing sumi with water in a suzuri.
The sumi stick is shown at an angle for clarity; in actual practice it must be held perpendicular.

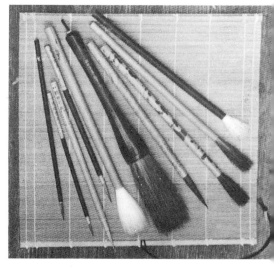

Various types of sumi brushes.

whose outer edges are suggested by the placement and the painting of the mountains. A fish is painted in such a way that it appears to be swimming in the water which, to the sumi artist, is the white paper. This is an art of suggestiveness, as well as of selectivity, and here the imaginative use of white paper plays a most important part.

One effective way to help visualize a black and white composition for sumi-e is to take a small piece of paper, say four by six inches, and cut out a small center section in rectangular shape, making a miniature frame. Looking through this you can "frame" sections of trees, groups of flowers, or a whole mountain against the sky to find the most interesting composition. Rarely will you want to center an entire tree in the middle of the frame; it will prove much more exciting to catch a part of the tree or vine on one side and let it run out of the picture, retaining eloquent areas of white "sky" within the frame.

Peering through this little frame, apart from its help in isolating interesting compositions, we may find a small insight into Oriental perspective—or the lack of it. Oriental art has never been overly concerned with the vanishing point nor with literal perspective in a given scene. The unpainted paper before a sumi artist is the given area which will receive whatever the artist chooses to put there. He is far less concerned with the fact that geographically there may be five mountains receding to a distant point than he is with their placement within the area of his paper. He suggests their distance by creating a vertical spacial relationship, elevating them on the single plane of the paper. Distant objects are invariably separated by areas of white paper, receding tones become weaker, and rugged, detailed lines of the foreground painting become softer and less distinct. It is as if one viewed a scene from two or three different angles at once. There are few limitations to this free visual and imaginative approach to landscape composition. The Oriental artist does not hesitate to move whole mountains, leave one out, or put one in where it does not exist. Once again, however, it is his knowledge and understanding of nature's manifold design which permits him to give free rein to his imagination on paper.

The sumi artist is equally unconcerned with values of light and shade such as we have grown accustomed to in most Western water-color painting. The flat and linear interpretation of sumi-e eliminates the necessity for the usual concept of the physics of light. In order to paint in this linear pattern one must first be able to view a scene in the same manner. Due to the restrictive values allowable in this simplified art, shadows do not exist, and the richest black tones of sumi are reserved for the more important elements of the linear design. Therefore, the most brilliantly sunlit roof in a village scene may become the blackest accent of the finished painting if this better suits the whole. In this economical monochrome painting the complications of light and shadow must be subordinate to the simplicity of brush-stroke line and flat-wash tones.

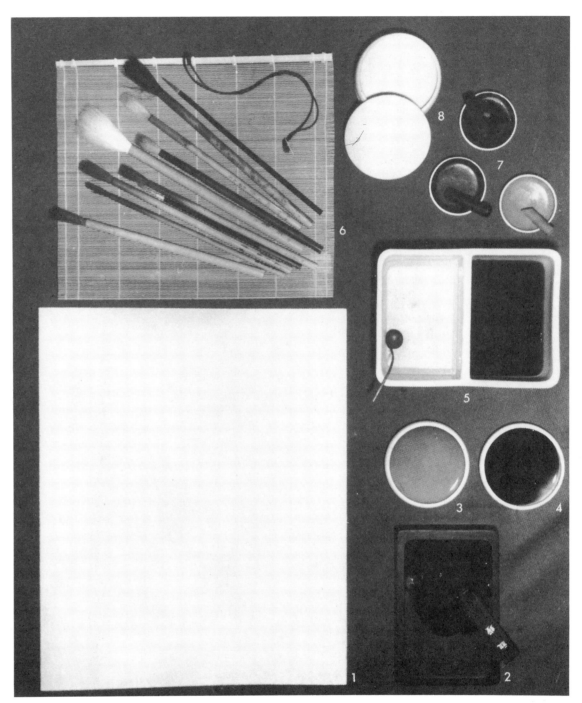

A convenient working arrangement of sumi-e equipment. 1) Paper mounted in the form of a shikishi. 2) Suzuri containing an ink stick and noboku. 3) Tamboku. 4) Chuboku. 5) Water container; the section with the tiny ladle is for clean water to be used in mixing inks, the other section for washing brushes and the like. 6) Brushes, on the bamboo screen in which they are rolled for storage. 7) Sticks of various colors, in the saucers used for grinding them with water. 8) Extra saucers, with the lid used on top of the nest of saucers when stored. Another desirable item, not shown here, is a rag for wiping brushes; the standard set of equipment includes a small tray for holding this.

sembyo: the way of a line

The linear brush stroke (Fig. 1), called *sembyo*, is the very essence of all Oriental ink-painting. Upon the success of this line depends the entire character of the painting. All sembyo strokes are painted quickly and freely, once the general direction and feeling have been visualized in the artist's mind. The artist strives toward a skilled "carelessness" in the control of the brush as the coordination between mind, eye, hand, and brush must be such as to give the resulting stroke living spontaneity, strength, and beauty.

These vital qualities of the brush line will be most quickly understood by beginning to practice without fear or hesitation. Hold the brush lightly but firmly toward the tip of its handle with the thumb and the first two or three fingers. Rinse the brush in clear water and absorb the excess on a slightly damp and absorbent paint cloth. Dip the brush into the prepared sumi mixture. For sembyo, the brush is held perpendicular to the paper. The stroke is sensed and directed through the fingertips, while its strength and flow come from the free motion of the entire arm and shoulder. This way of painting, using a minimum of wrist movement, enables the artist to achieve the unhesitating flow which must be evident in every section of the sumi line. Paint a straight stroke, swiftly but steadily, with equal brush pressure, in different directions on a sheet of practice paper. If the line is painted too slowly it will be shaky and unsure. The line need not be ruler-straight but will have interest in character and sensitivity rather than mechanical perfection.

When one has absorbed the feel of this free-flowing line, all the many variations which follow are a matter of changing stroke direction, varying the degree of pressure of the brush on the paper, interplaying the amount of moisture and sumi on the brush, and changing the different sizes and types of brushes used for contrast in size and texture.

For example, the circle in Fig. 2 is the same sembyo stroke, but it follows a circular motion of the hand, arm, and shoulder in one continuous stroke. It, too, has strength and character rather than compass precision. And the sweet peas of Fig. 3 are done entirely in variants of the basic sembyo stroke.

By changing the direction of the brush stroke and by varying the pressure of the brush it is possible to achieve, in continuously flowing strokes, limitless variations of the sembyo line, depending on one's capability, imagination, or perhaps simple courage! The line may express a delicate and fragile tendril-like growth (Fig. 4), using a thin brush with a change in direction and with little change in pressure. It may also suggest the infinite subtleties of an aged vine by alternately lifting and pressing a larger brush to the paper so that all the bristles combine in painting a broader line (Figs. 5 and 6).

Many other variations of the sembyo line are seen in the strong yet sensitive structure lines which support the softer wash tones of sumi-e, called *mokkotsu*, shown on pages 14 and 15.

Ukai Uchiyama demonstrating the correct brush grip.

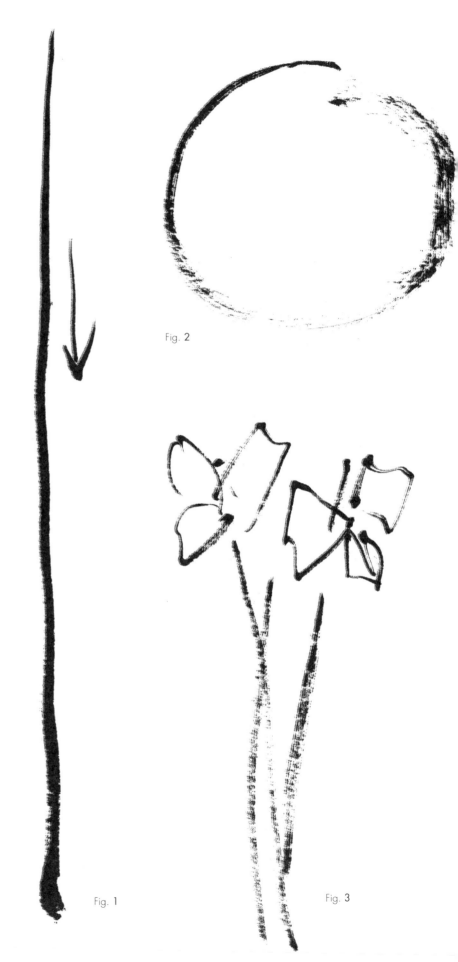

Fig. 2

Fig. 1

Fig. 3

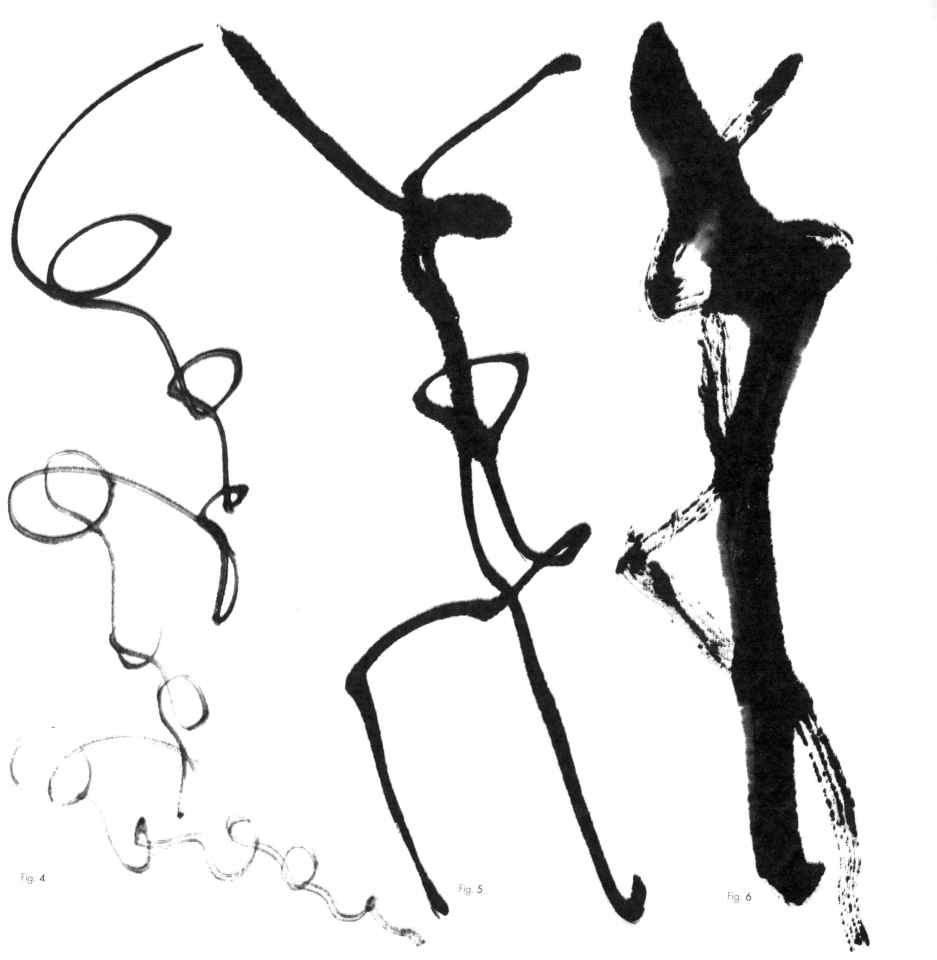

Fig. 4

Fig. 5

Fig. 6

mokkotsu: wash stroke

Mokkotsu is the soft wash stroke of two or three tones which, in combination with sembyo, forms the basis of all sumi-e techniques.

Usually a brush with soft bristles is used for mokkotsu. After moistening the brush, dip one side into the middle value, or chuboku. Then, turn it over and dip the tip into the deepest black, or noboku, so that it is loaded as illustrated in Fig. 1. Hold the brush lightly but firmly near the top of its handle with the thumb and two or three fingers, but tilt it at approximately a thirty-degree angle so that the length of the bristles touches the paper as well as the tip. Then, as you start to paint, turn the brush on the side during the stroke, creating a gradation of tone with each separate stroke (Fig. 2). Continue painting with the same brushload as long as possible before reloading, thereby obtaining the maximum variety of tonal gradation as the sumi diminishes. Accidental white areas, where the brush leaves the paper, are to be welcomed as they too add interest and spark. A little practice will show the artist just how to fill the brush for the best results; the brush should be wet enough to flow freely, permitting the ink to blur here and there where such softness is desired.

One of many possible combinations of sembyo and mokkotsu is shown in Fig. 3. Here, as usual when rendering large leaves, the procedure is to paint the stem first, using a firm sembyo stroke and a hard brush and noboku. Then change to a larger and softer brush, and having freshly loaded it as previously described for mokkotsu, paint the body of the leaf in wash strokes away from the center, or main stem, of the leaf. These strokes bear slightly forward toward the tip in the natural direction of a growing leaf, but the strokes are free and irregular, resulting in a varied contour. Before the mokkotsu strokes are completely dry, change to a small, hard brush and noboku for indicating the smaller veins, which should blur slightly on the still-moist sumi of the mokkotsu.

Fig. 4 shows another combination of sembyo and mokkotsu: smaller leaves where the strokes go along in the same direction as the stem and appear to be slightly rounded due to a change in brush pressure. In this case it is better to paint the stem last, after establishing the twist of the leaf. The brush tip touches the paper first; then the full width of the bristles is brought to bear down briefly before being lifted again. These two swift strokes establish the leaf's contour; in the first the dark tip of the brush forms the outer edge of one side of the leaf, and in the second the same dark tip forms the inner center. Stem and veins are added with a hard brush and noboku.

Tiny leaves (Fig. 5) may be simply one-touch strokes of mokkotsu with one-touch strokes of sembyo. In its simplest combination, such as the sweet pea of Fig. 6, the pale mokkotsu strokes of the petals complement the swift black lines of sembyo in the economy of suggestion that forms the essence of sumi-e.

Other combinations of sembyo and mokkotsu as seen on following pages are elaborate and complicated versions of the basic combinations described here.

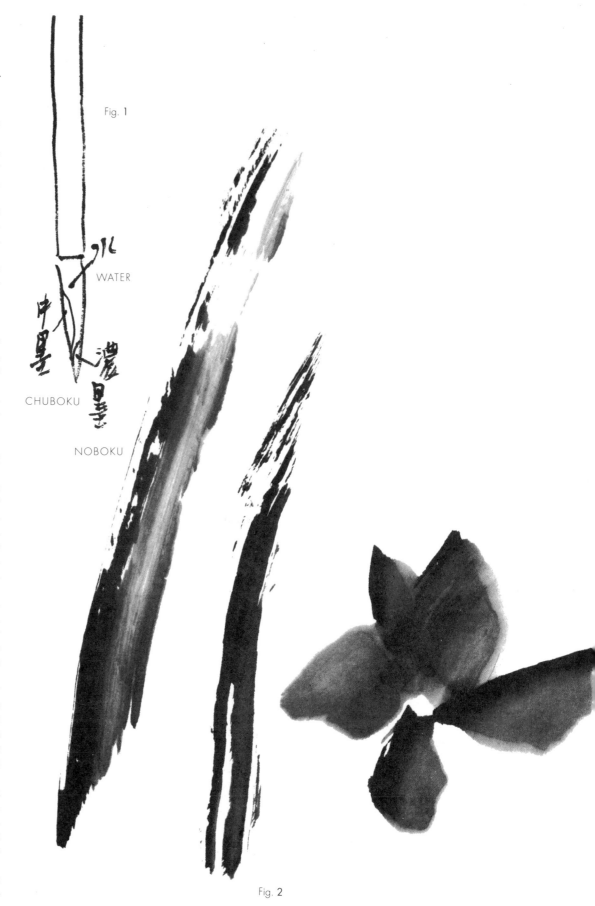

Fig. 1

WATER

CHUBOKU

NOBOKU

Fig. 2

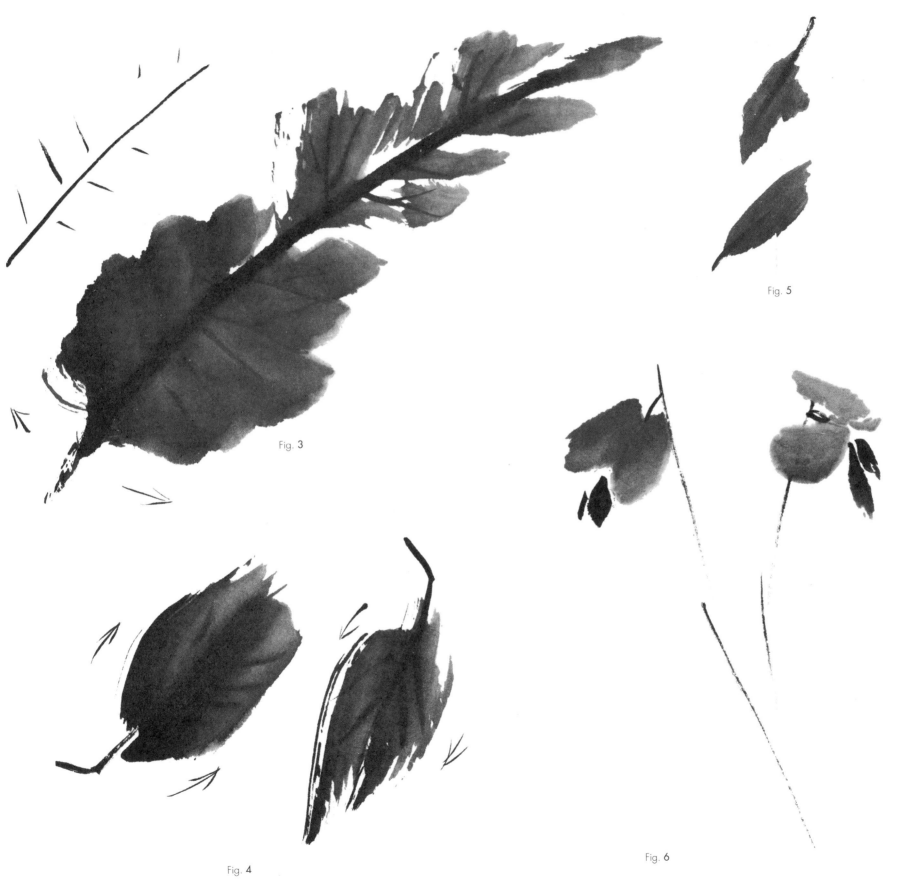

Fig. 3

Fig. 4

Fig. 5

Fig. 6

Fig. 1

iren: continuous calligraphic motion

Oriental calligraphy, whether or not one understands the meaning of the characters, is a brushwork design of abstract beauty (see, for example, the end papers of this book). Mr. Uchiyama, a master calligraphist as well as sumi artist, employs many of the strokes and underlying rhythms of calligraphy in the painting of visual subjects. The very qualities which give continuity, beauty, and fluency to his calligraphy also generously appear throughout this writing-painting we call sumi-e.

One of the more valuable contributions of calligraphy to sumi painting is that quality referred to as *iren.* Iren is the continuation of the arm movement *between* the strokes visible on the paper. Due to the flow of this unbroken motion, there is no shaky pause of indecision as to where the next stroke will begin; one stroke flows naturally and rhythmically into the next.

In Oriental calligraphy, this continuation of stroke movement is part of the logical construction of the written character. In the student's copybook, each character is shown in the consecutive order of its stroke construction, a logical progression from start to finish. The strokes are numbered, and are sometimes connected with a dotted line to show the continuous motion of the brush and arm between these strokes during the time the brush is raised from the paper.

In Fig. 2 the calligraphic character for *naka,* "middle," illustrates this continuation of motion between strokes. The same flowing rhythm of iren in sumi painting may be recognized most clearly in the strokes of the wild orchid, as in Fig. 3. The calligraphic techniques of this honored flower of Japan are described more fully on pages 20 and 21.

Iren, however, is more than just a numbered order of strokes. This numerical sequence serves as a suggestion for the flowing action of the sumi brush. This brush action is one of the important and unique qualities of sumi painting. In other forms of art the physical manner in which the paint is applied to the paper or canvas is of relatively minor importance to the finished work. In sumi-e it is an integral part of the painting itself.

The excitement of this action-painting may best be understood by experimenting with a series of free strokes like those of Fig. 1. Swinging your arm in a series of variegated oval motions, bring the brush to the paper in sections of this oval motion and note that the strokes seem to fall almost naturally into a pleasing pattern. More realistically, these same strokes might lend themselves to an impression of graceful willow branches as in Fig. 4. The willow leaves, while differing in brush pressure and length of stroke, are also the patterned result of the free-swinging circular arm motion of iren.

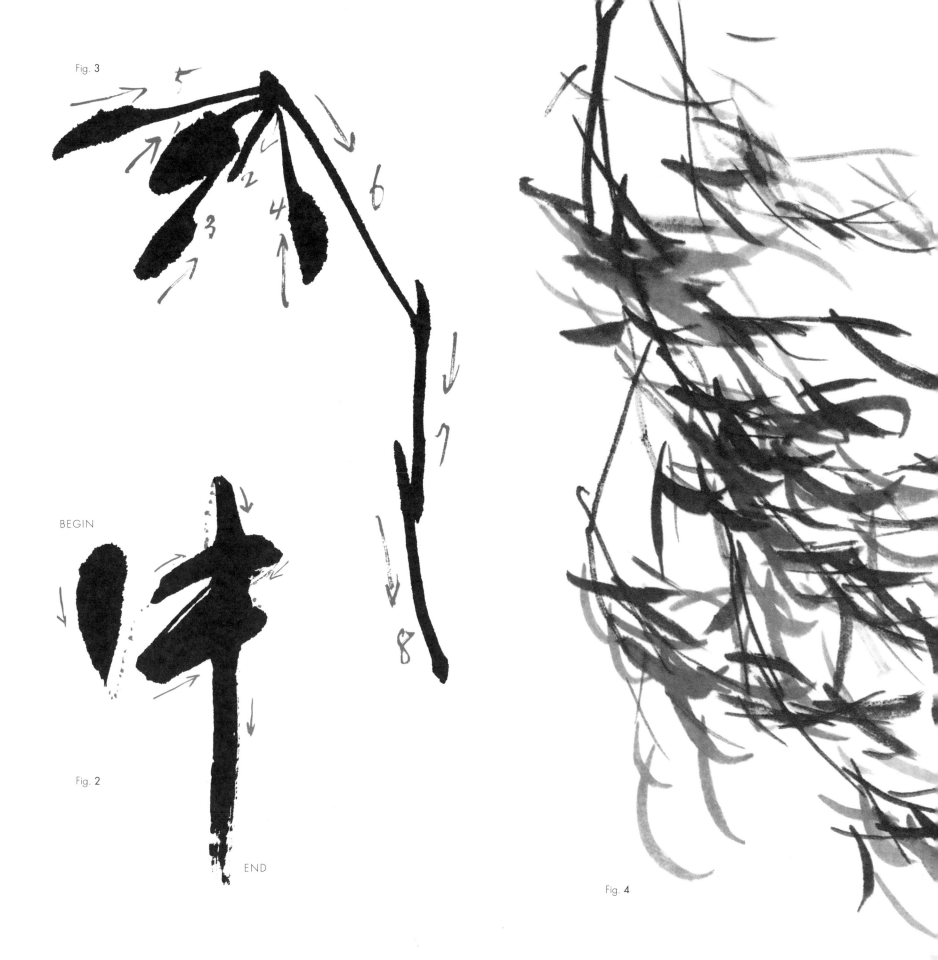

Fig. 3

5

1

2

3

4

6

7

8

BEGIN

END

Fig. 2

Fig. 4

grass strokes

Long blades of grass (Fig. 1) virtually suggest their own technique. Each blade is an unhesitating, curving, upward stroke of the brush, guided by the natural continuous motion of iren as described on page 16. In the interests of composition, a cluster of grass may best be painted as emanating from a single visual source. Grasses tend to incline in one general direction but, in painting, one or two strokes in the reverse direction sometimes add interest. Shorter, new-grown grass (Fig. 2) assumes a sturdier character and finds expression in abrupt little downward strokes. Such contrasts of line technique as illustrated by these two grasses frequently appear together in one painting, the staccato accent of the one complementing the flowing grace of the other.

The infinite twists and turns of longer grassy reeds are familiar in their beauty to every nature observer. Ancient Chinese sumi artists had interesting names for each section of this natural design. The main grass stroke of Fig. 3 illustrates three main sections, all painted in one skillfully controlled sweep of the brush. This stroke is begun with a "nailhead," a slight pressure of the brush to the paper held momentarily before continuing to the second section. Here, the brush does not leave the paper but is abruptly raised to a thin point, immediately descending once more to become the broadest section of the grass. This section is known as *toroto,* or "mantis body."

Again the brush is lifted without leaving the paper and the stroke tapers off to a thin point in the third section, known as the "rat tail." This entire brush action consists of controlled manipulation of the pressure of the bristles against the paper in a sensitive expression of natural growth.

The groupings of strokes shown in Figs. 4 and 5, so often noted in nature, also have the distinction of their own names in the sumi-e vocabulary. Crossing the main, or twisted stroke, invariably is a second and less compli-

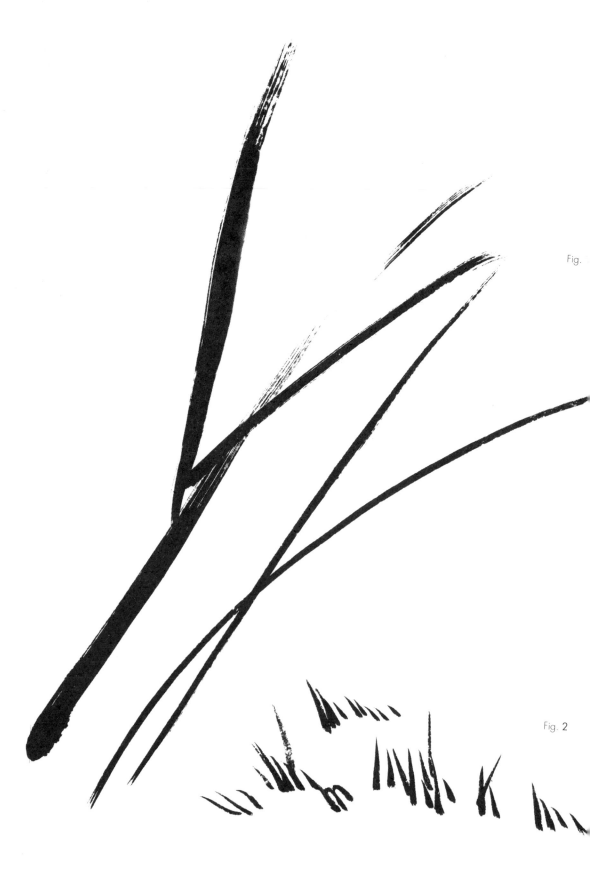

Fig.

Fig. 2

cated one. This grouping is called *hogan,* "phoenix eye," because of its resemblance to the eye of a bird (Fig. 4). When yet another stroke crosses between these two, it becomes *hahogan,* "sundered phoenix eye" (Fig. 5).

The hahogan grouping is a traditional composition growing out of centuries of observation and painting on the part of many successive Oriental artists. There are many variations of design in nature and this particular formation may be noted in tree branches, vegetables, and flowers as well as in the grasses. Looking around, one will find countless examples of the "phoenix eye" supplying inspiration and suggestion for linear compositions.

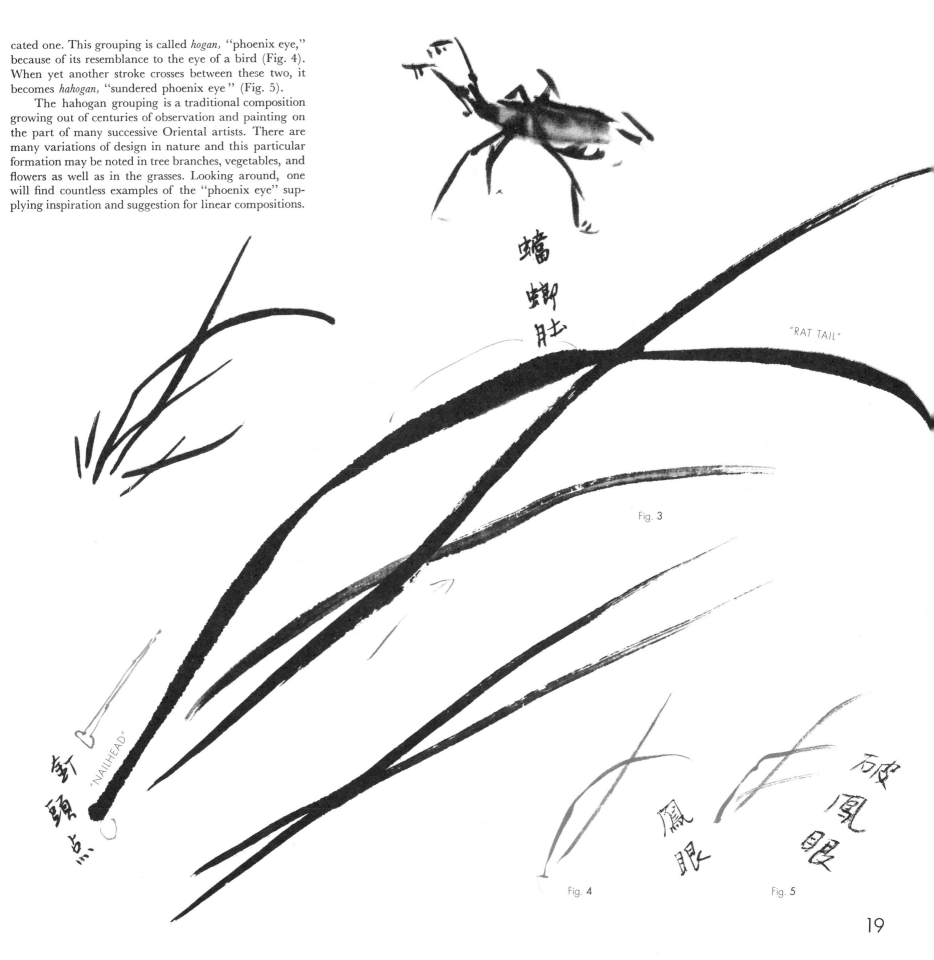

"RAT TAIL"

"NAILHEAD"

Fig. 3

Fig. 4

Fig. 5

shikunshi: the four gentlemen of Japan

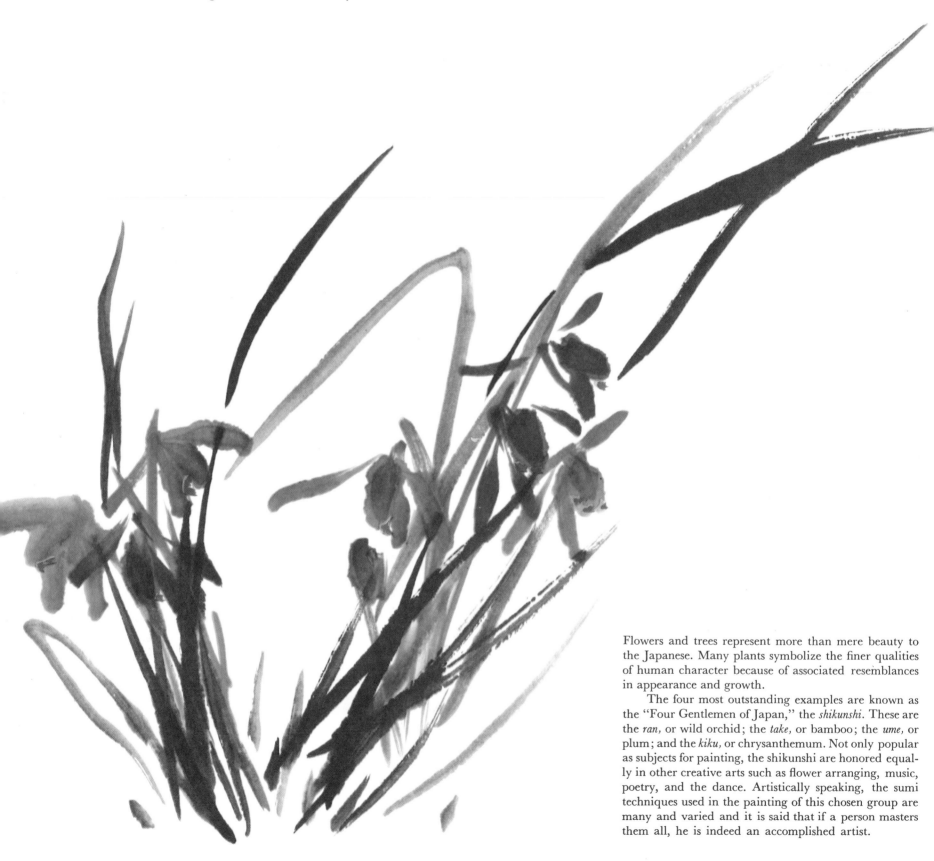

Flowers and trees represent more than mere beauty to the Japanese. Many plants symbolize the finer qualities of human character because of associated resemblances in appearance and growth.

The four most outstanding examples are known as the "Four Gentlemen of Japan," the *shikunshi*. These are the *ran,* or wild orchid; the *take,* or bamboo; the *ume,* or plum; and the *kiku,* or chrysanthemum. Not only popular as subjects for painting, the shikunshi are honored equally in other creative arts such as flower arranging, music, poetry, and the dance. Artistically speaking, the sumi techniques used in the painting of this chosen group are many and varied and it is said that if a person masters them all, he is indeed an accomplished artist.

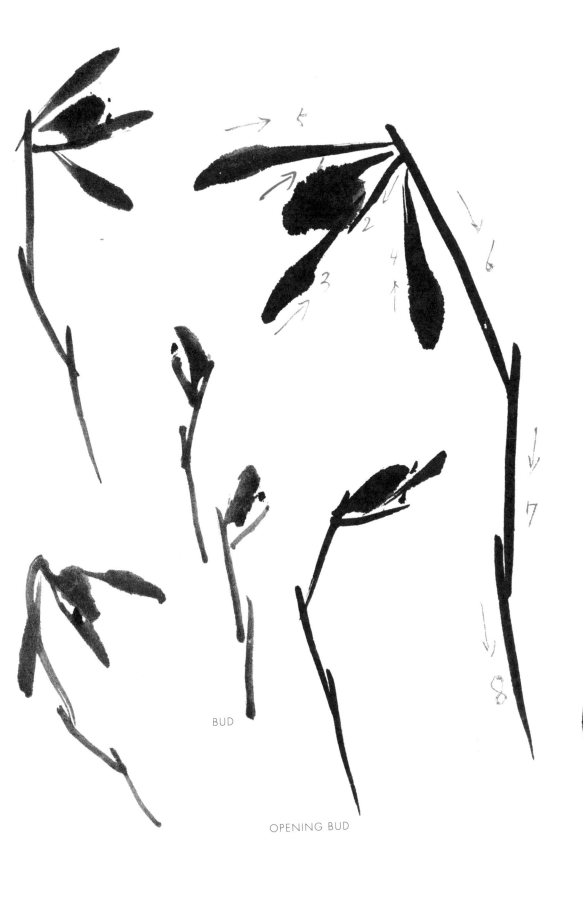

ran, the orchid

The first of the shikunshi, the wild orchid, is unlike the Western cultivated orchid. It is small and delicate, growing deep in mountain recesses. It is greatly admired for its quiet beauty and is considered a symbol of true nobility—humble and modest.

The techniques for painting this delicate blossom are closely associated with calligraphy, as already mentioned on page 16. To begin, select a medium-sized, soft brush and, after dipping it in clear water and absorbing the excess on a cloth, first press one side of the brush in chuboku, the middle tone; then turn it over and very slightly touch the tip in noboku, the darkest tone. Start with the center of the flower. Stroke No. 1 is a pressure stroke of the brush which suddenly lifts to a thin point. This is followed by No. 2, a thin stroke in the opposite direction, and back again with stroke No. 3, in between Nos. 1 and 2. Nos. 4 and 5 both converge toward the center of the blossom with the pressure of the brush at the beginning of the stroke, as in 1 and 3. After completing No. 5, and without interrupting the motion, continue to the stem with Nos. 6, 7, and 8. Once familiar with the order of these strokes, the artist will be able to paint them in rapid succession, twisting and turning the little flower to express the moods of the weather or the mood of the painting.

The grassy leaves of this orchid plant are similar to those on the preceding pages and show the use of calligraphic iren as well as of hahogan. In the sensitive grouping on the facing page, the leaves were painted first to establish the composition. A sumi artist rarely centers his subject on the paper, but instead keeps the important interest off to one side, leaving ample white area to enhance the beauty of the lines.

If one wishes to use color, it is well that it be confined to the blossom itself. Here, the artist has used green, the natural color of this orchid, with small accents of red. When using color, the tonal values are the equivalent of those of the black sumi, again in three shades: dark, medium, and light.

BUD

OPENING BUD

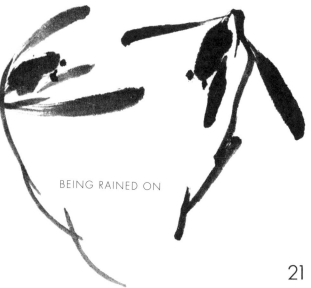

BEING RAINED ON

21

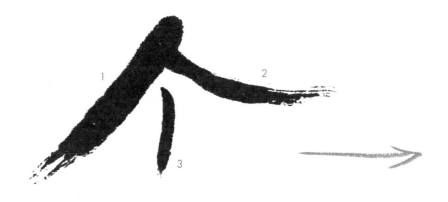

také, the bamboo

The beautiful bamboo, green at all seasons, suggests constancy, sturdiness, and adaptability. It provides a graceful contrast to its frequent neighbor, the straight pine. Caught by the wind, a bamboo grove may gently sway and bend, but this apparent delicacy belies its durable strength. These same characteristics of grace and strength extend themselves to the painting techniques.

Essentially calligraphic in approach, the strokes of the bamboo leaves are variations of the three written characters shown to the right—*ke* (a phonetic), *bun* ("to divide"), and *kai* ("to lie between")—from which the techniques derive the names shown here. While the characters' literal meanings are of no concern to the artist, a better understanding of ink painting will be grasped through practice of these calligraphic strokes. When eventually used in a finished painting of bamboo, the characters will become illegible, but the motion of their construction will have imparted a rhythmic, fluid, calligraphic beauty to the artist's brush strokes.

For the first character, begin with the downward stroke on the left. Without interrupting the motion of the arm, continue around to the left and up, crossing the first stroke to make the second stroke. Still not pausing, the arm proceeds up to the left, around and down for the brief third stroke between 1 and 2, which completes the character. The other two characters are "written" in a similar manner, with the addition of a fourth stroke, which also becomes a part of the continuous motion.

A familiarity with these three characters assures subtlety and control. Neither straight nor limply curving, each line has strength and freedom without the loss of controlled direction and sensitive beauty. For the artist who is unfamiliar with the written rhythm of Oriental calligraphy, the writing of these characters will accentuate the importance of iren and the gentle but firm control of the brush. Gradually, as these motions become almost second nature, they can be painted with greater freedom and speed, retaining only the feeling, motion, and rhythm of the original calligraphy. Variations of tonal strength and the amount of sumi and moisture on the brush will contribute additional interest to the brushwork pattern of such calligraphic bamboo leaves.

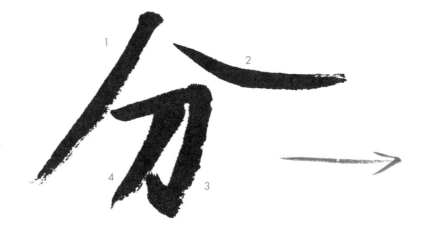

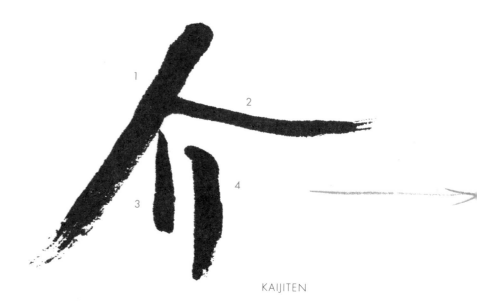

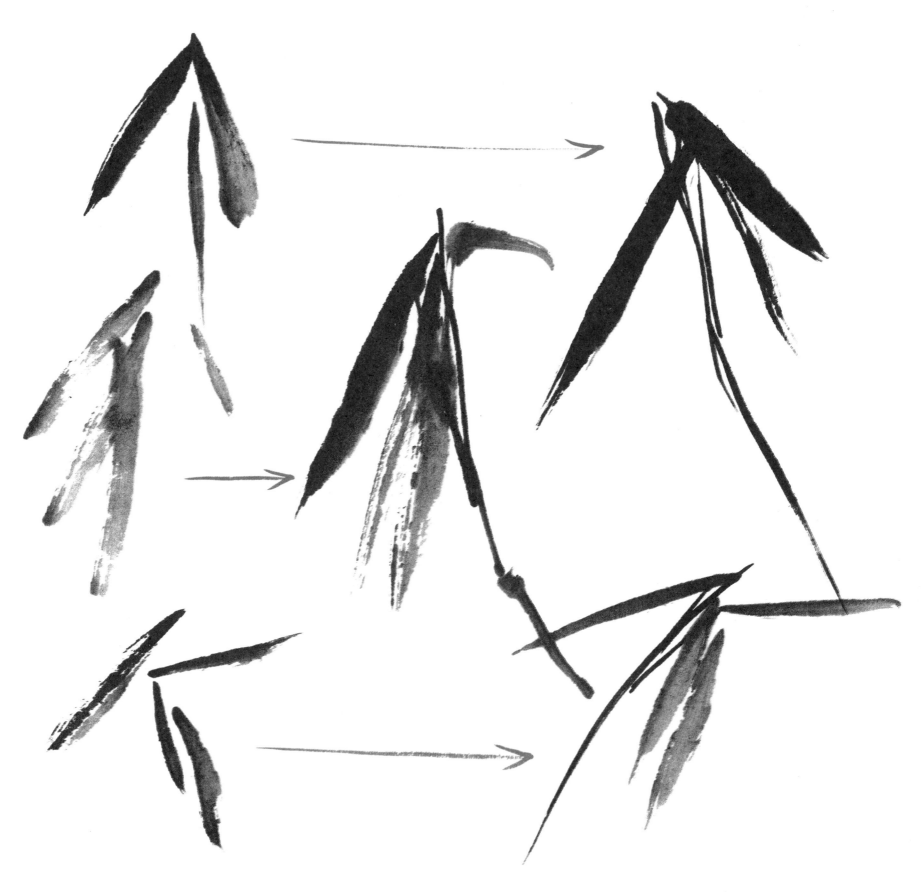

In contrast to the soft mass of bamboo leaves, the trunk may be seemingly rigid. Strong and straight in itself, it tapers in graduated smooth-surfaced sections, separated by circular ridges. Noted for its serene beauty, it is also a tree of many uses; for example, as handles for the very brushes of sumi-e.

The choice of a brush is largely a matter of personal preference, since each will produce a different effect. For a thick stem (Fig. 1), fill the brush with chuboku on one side and a smaller amount of noboku toward the tip of the other side. Take care that the brush is not too moist as excessive blur is not desirable for the bamboo trunk. Holding the brush in a nearly vertical position, begin at the bottom and bring the full pressure of the bristles immediately to the paper and continue upward with the full length of the bristles contacting the paper. Keep an even pressure, steady strength, and unhesitating degree of speed. Break the stroke at increasingly wider intervals as the bamboo nears the top. These are deliberate and clear breaks which follow each other with unbroken motion and speed so as not to lose the tapering flow of the tree. While each stroke appears straight in itself, the arm follows a gradual curve that suggests the graceful resilience of the bamboo.

Paint the joint line in between the sections with a small hard brush dipped in noboku, keeping it rather dry. This joint line, called *otsujiten* (Fig. 2), is not a smooth curve but an angular, rugged accent which enhances the smooth surface of the bamboo trunk. From these joints emerge straight little offshoots, called "deer horns" (Fig. 3), painted freely with a very thin little brush and noboku.

Young and thin bamboo trees (Fig. 4) or those of a grove seen at a distance are painted in sembyo lines in downward strokes.

Bamboo sprouts (Fig. 5) are painted with alternating downward strokes which curve towards each other. Noboku touches are then added for accent.

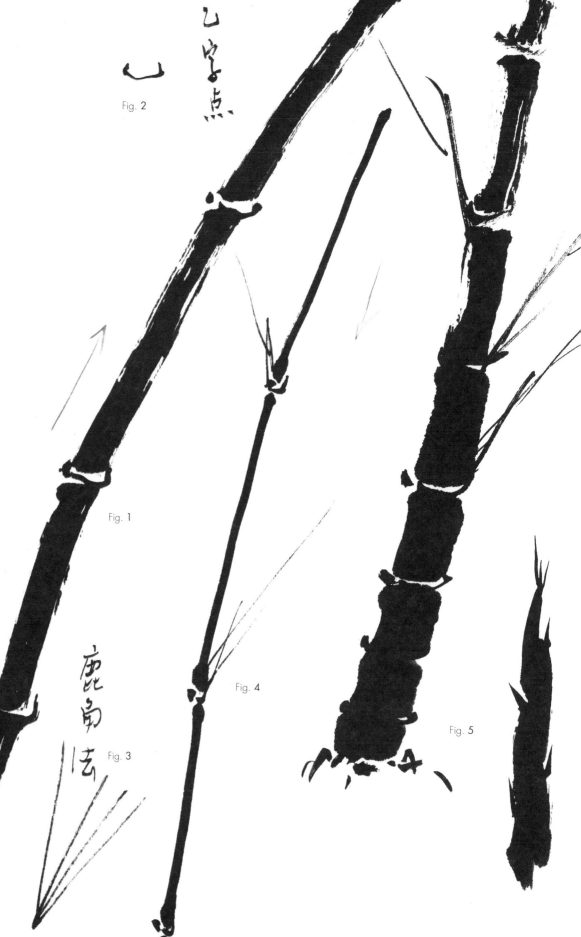

Fig. 2

Fig. 1

Fig. 4

Fig. 3

Fig. 5

24

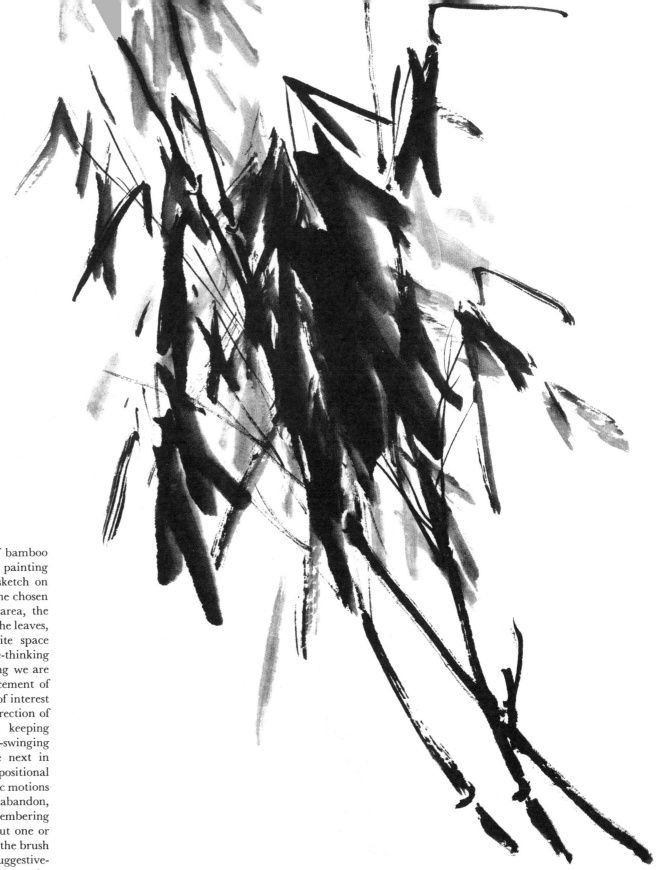

After practicing the separate techniques of bamboo leaves and trunk, combine them in a finished painting like the one shown here. First make a pencil sketch on another paper of the same proportions as the one chosen for the painting, thus establishing the pattern area, the main swing of the trees, the general massing of the leaves, and, no less important, the areas of open white space which give air and depth and "sky." This pre-thinking is essential: when it comes to the actual painting we are then no longer concerned with the exact placement of each leaf but can "feel" where the main area of interest will be concentrated along with the general direction of the main bamboo trunks. Paint these first, keeping in mind, as always, a larger conception of free-swinging iren when progressing from one trunk to the next in order to help realize a more natural flow in compositional compatibility. Then, using the three calligraphic motions for the leaves, begin to paint with seeming abandon, allowing feeling to dominate thinking, remembering only that the richest blacks should cluster in but one or two places, while the paler strokes, produced as the brush grows drier, serve as outer softness and depth suggestiveness. Once commencing to paint, a sumi artist must be unhesitant and confident.

25

umé, the plum

The blossoming plum tree is the first herald of coming spring, frequently appearing even before the last snow has entirely disappeared. To the contemplative Japanese the analogies of the plum tree are numerous. The dark, jagged trunk represents old age, while the new green shoots and fresh blossoms in the spring are evidence of life's constant renewal and fresh hope. The pale blossoms are also associated with women as a symbol of purity and loyalty.

The trunk, in contrast to the smooth bamboo, is irregular and unpredictable in its construction. Hahogan, the crossing of lines, will show itself in a more angular form than in the grasses on pages 18 and 19. Use a large brush preferably with hard bristles, touching it in chuboku on one side and a generous amount of noboku on the other. With one strong, irregular stroke, paint the trunk with a feeling for its ruggedness. Branches grow from the trunk in appropriate proportion to their position. Before these strokes are completely dry, accent the rich bark with nobs of noboku, thus accenting the rough surface of the old tree. These dots are called *beiten* (i.e., like the dots in the character *bei*, "rice") and are frequently seen on trees and mountains in Oriental painting.

The blossoms may be painted either in sembyo outlines or in color mokkotsu. The petal strokes in sembyo are two curving lines for each of the five petals (Fig. 1). The center of the flower, which, according to Chinese legend, resembles a dragon's eye, is a circle with a central touch of black. This is surrounded by delicate line strokes, dotted here and there at the tips (Fig. 2).

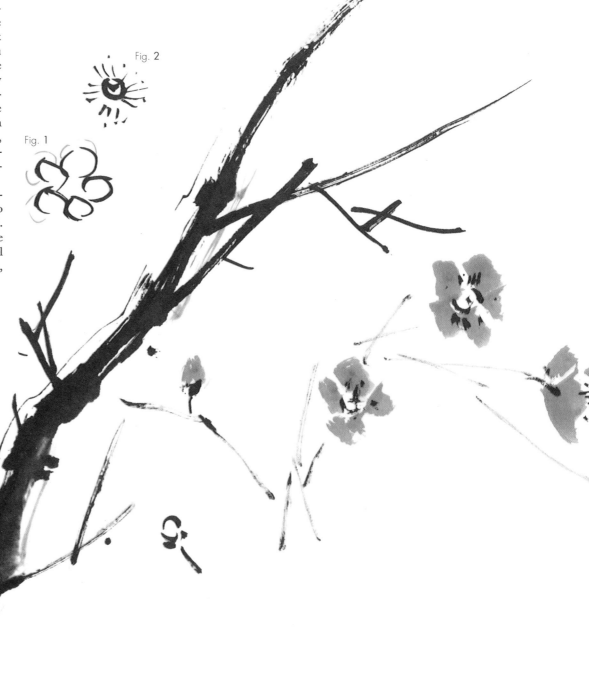

Fig. 2

Fig. 1

Fig. 3

26

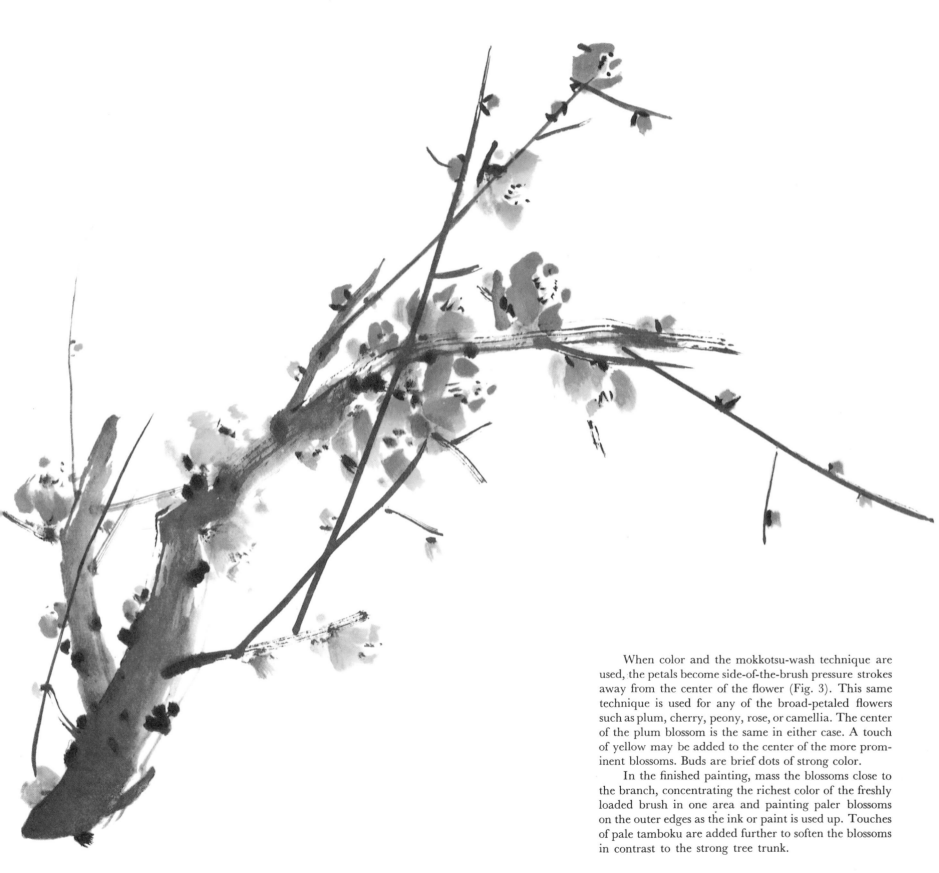

When color and the mokkotsu-wash technique are used, the petals become side-of-the-brush pressure strokes away from the center of the flower (Fig. 3). This same technique is used for any of the broad-petaled flowers such as plum, cherry, peony, rose, or camellia. The center of the plum blossom is the same in either case. A touch of yellow may be added to the center of the more prominent blossoms. Buds are brief dots of strong color.

In the finished painting, mass the blossoms close to the branch, concentrating the richest color of the freshly loaded brush in one area and painting paler blossoms on the outer edges as the ink or paint is used up. Touches of pale tamboku are added further to soften the blossoms in contrast to the strong tree trunk.

27

kiku, the chrysanthemum

The magnificent chrysanthemum is so beloved by the Japanese that it has been the emblem of the Imperial Family since the tenth century. It is also considered a symbol of family life in its circular formation and is admired because in the autumn, when all else in nature gives up until spring, the kiku comes forth in its most brilliant colors.

Of the many varieties that have been developed, one of the more interesting as a painting subject is the large and rather shaggy-petaled blossom, which lends itself beautifully to sumi techniques. It is hoped that the artist is fortunate enough to have one of these blossoms for study. The brush selected for the petals may be either hard or soft; each gives a different effect. When painting either in ink monochrome as here or in color as on page 30, the brush is loaded in the same manner, with the medium and the dark tone. In color, an interesting combination is yellow on one side with a touch of orange on the other. The leaves remain black.

The strokes follow the construction of the flower. Begin in the middle with curving downward strokes which, as they near the outer edge, gradually grow larger and more irregular. These strokes all radiate from the flower's center. The larger petals on the outside may be either upward or downward strokes. A variety in the length of the strokes, even in the more regular blossoms, prevents monotony, as also does a variety of tonal values.

The strong single stroke of the stem requires much skill since its quality, placement, and direction can either make or ruin the painting. A chrysanthemum stem has no exaggerated twists or bends, nor is it a straight, unfeeling stick. With a hard brush and noboku, begin the stroke at the base of the flower and proceed downward, drawing the stroke toward you. The stem must appear strong enough to support the weight of the blossom without appearing too heavy. It is a swift but thoughtful stroke embodying the taxing qualities of a true sembyo line.

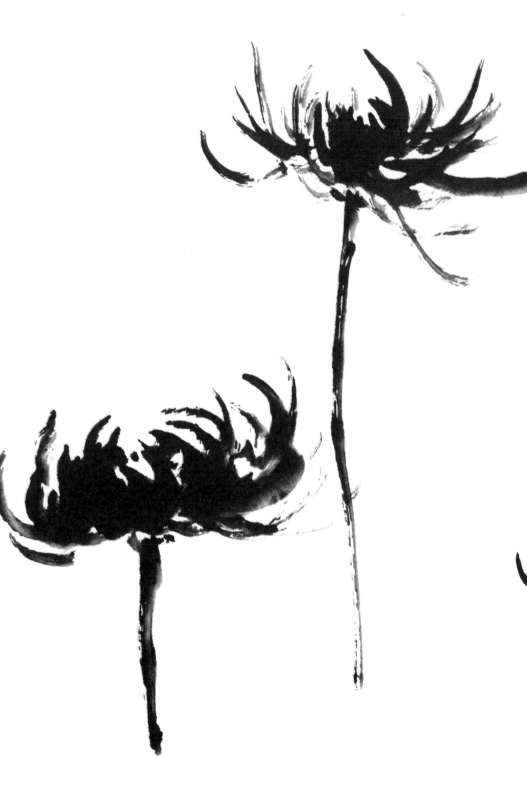

28

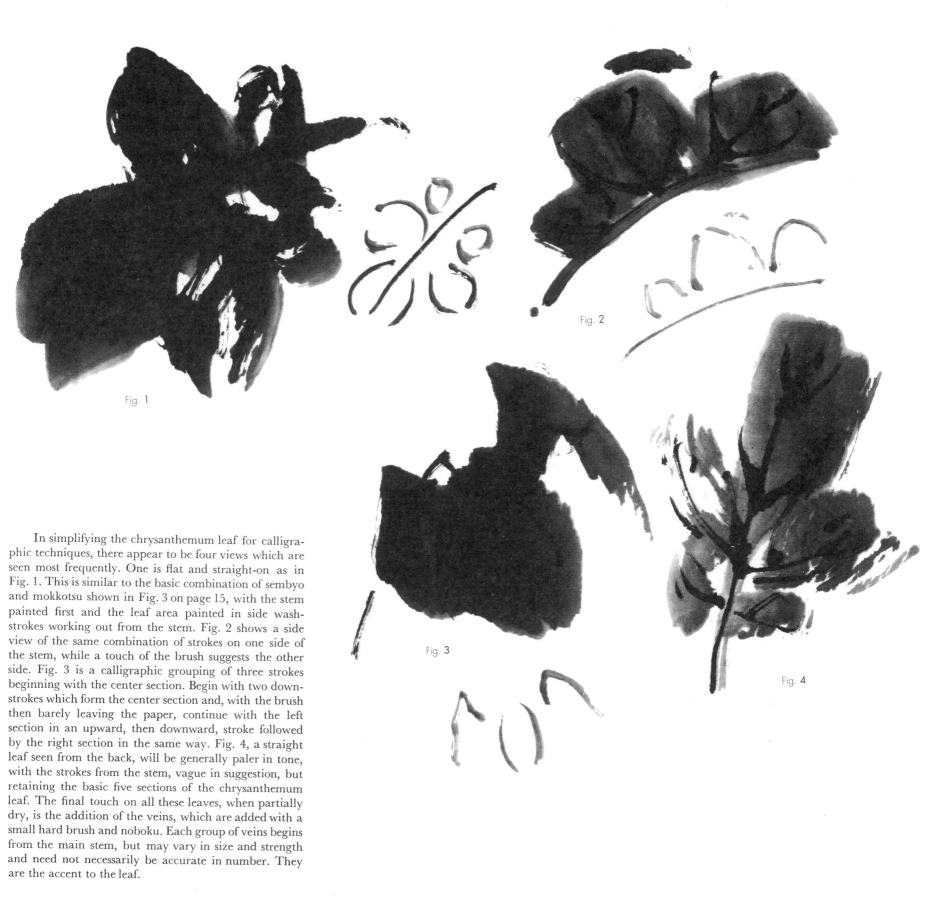

Fig. 1

Fig. 2

Fig. 3

Fig. 4

In simplifying the chrysanthemum leaf for calligraphic techniques, there appear to be four views which are seen most frequently. One is flat and straight-on as in Fig. 1. This is similar to the basic combination of sembyo and mokkotsu shown in Fig. 3 on page 15, with the stem painted first and the leaf area painted in side wash-strokes working out from the stem. Fig. 2 shows a side view of the same combination of strokes on one side of the stem, while a touch of the brush suggests the other side. Fig. 3 is a calligraphic grouping of three strokes beginning with the center section. Begin with two down-strokes which form the center section and, with the brush then barely leaving the paper, continue with the left section in an upward, then downward, stroke followed by the right section in the same way. Fig. 4, a straight leaf seen from the back, will be generally paler in tone, with the strokes from the stem, vague in suggestion, but retaining the basic five sections of the chrysanthemum leaf. The final touch on all these leaves, when partially dry, is the addition of the veins, which are added with a small hard brush and noboku. Each group of veins begins from the main stem, but may vary in size and strength and need not necessarily be accurate in number. They are the accent to the leaf.

When combining two or more chrysanthemums, or any group of flowers, it is well to keep the color in one area or in groups of areas; otherwise the painting may become spotty. The leaves also, in such a painting, should blend together to create patterned areas of the dark and the pale tones. More than a botanical study, a sumi painting is a sensitive arrangement of tonal values simulating the specific subject which is the object of inspiration. If painting from an actual flower, which is highly desirable, the artist need not hesitate to add leaves where they do not exist or ignore them where they do if this better suit the feeling of the painting. It is the combination of tones on the white paper which creates the painting—a creation of itself, springing from, but independent of, nature's creation.

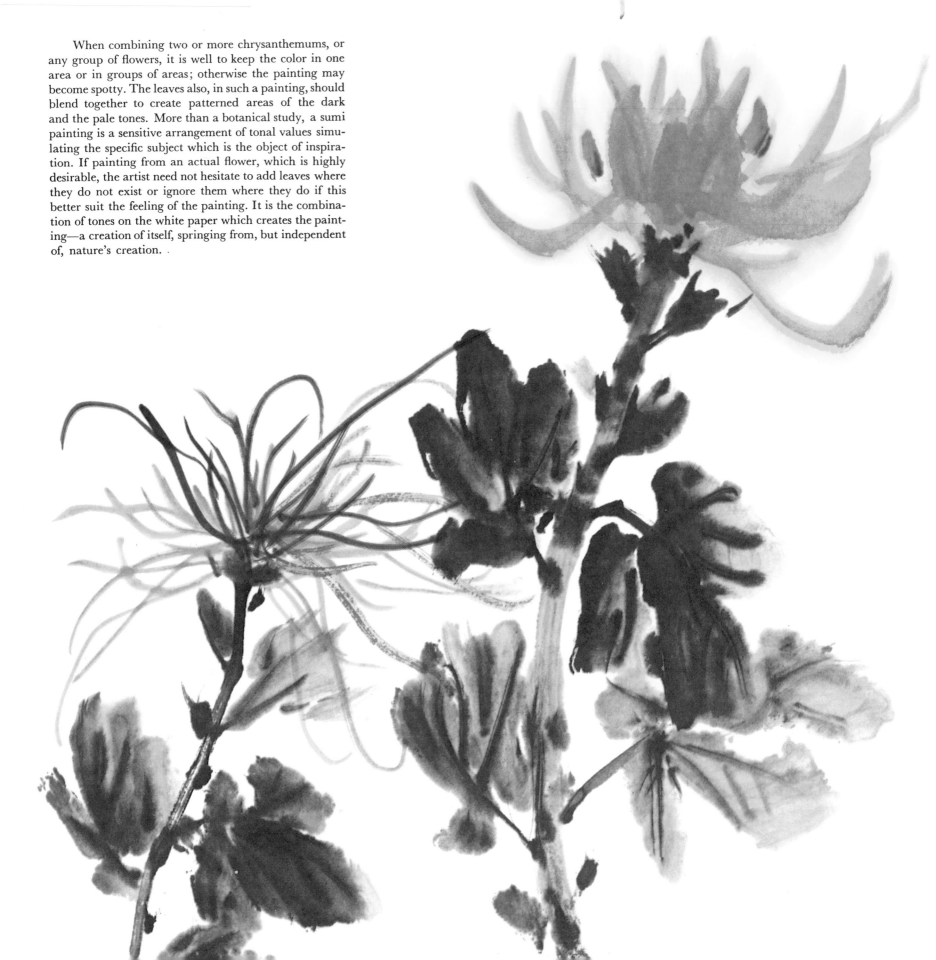

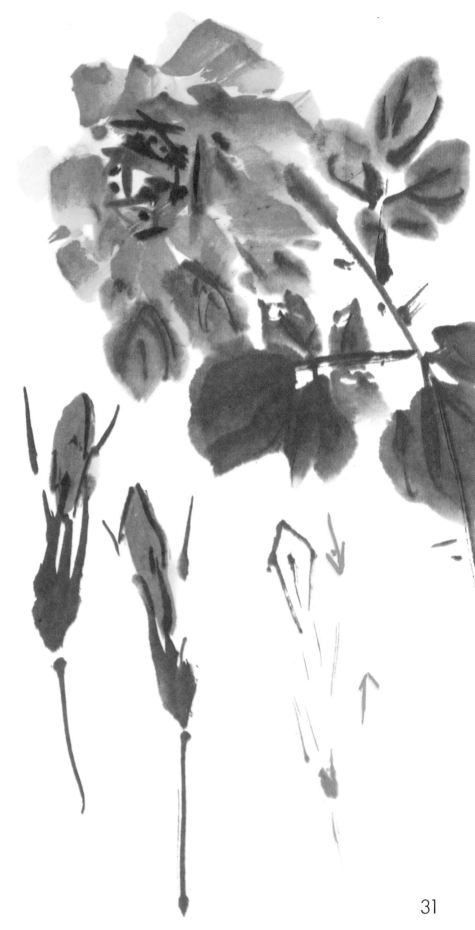

the rose

While the rose is not considered a typically Oriental flower, it is shown here to point out the fact that sumi techniques may well suggest flowers native to other lands.

There is a similarity between the rose's petal and that of the plum. Dampen a soft brush and dip in a rich red paint. Press it sideways to the paper in a cluster of straight, crossing strokes, which form the center of the flower. Gradually, as the petals widen, increase the width of the stroke more and more, working away from and around the center of the flower. Use all the paint on the brush before reloading, keeping the deepest tones nearer the center. Add a touch of yellow to the center and black lines and dots for accent. The stem is a downward sembyo stroke. Each leaf is composed of two mokkotsu strokes and generally five of these are grouped on each leaf stem. Sharp touches of a small brush with noboku indicate veins and thorns.

The rosebud is one pressure stroke in the deepest color. Leave a white separation and paint the base of the bud with noboku in upward strokes adding a suggestion of outline to the bud.

Paint as many varieties of the rose as possible, noting the characteristics of each.

31

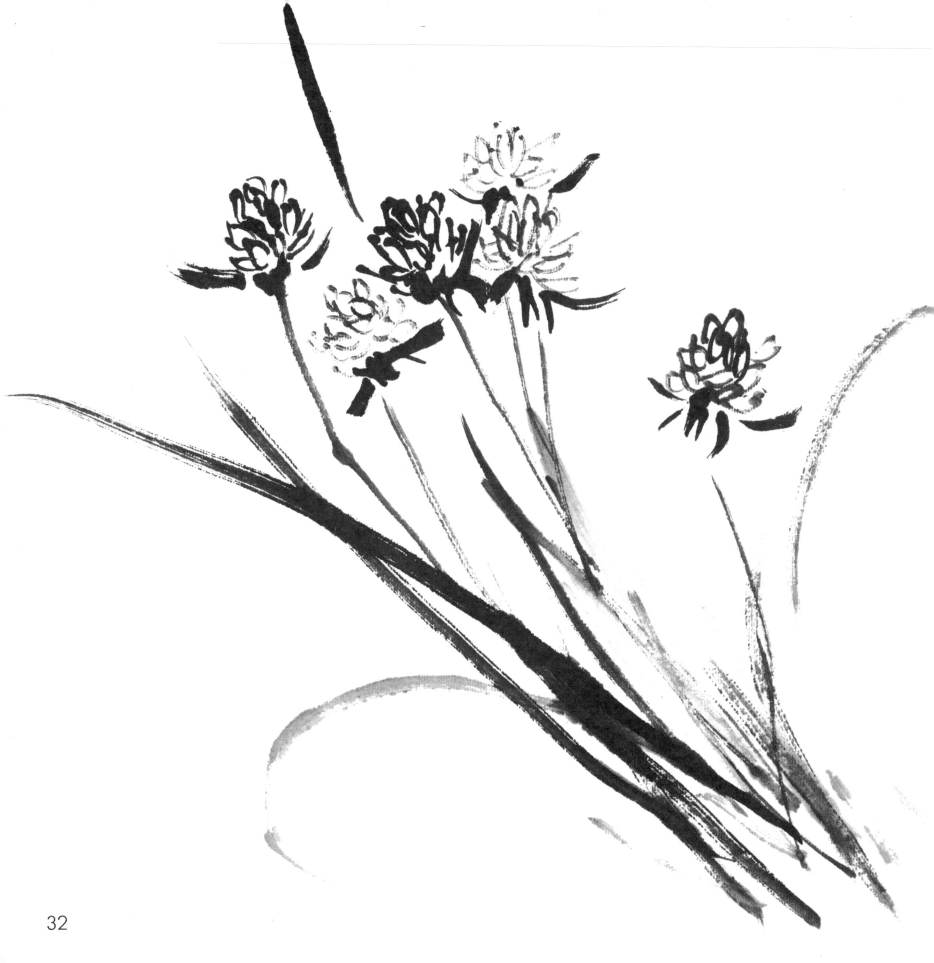

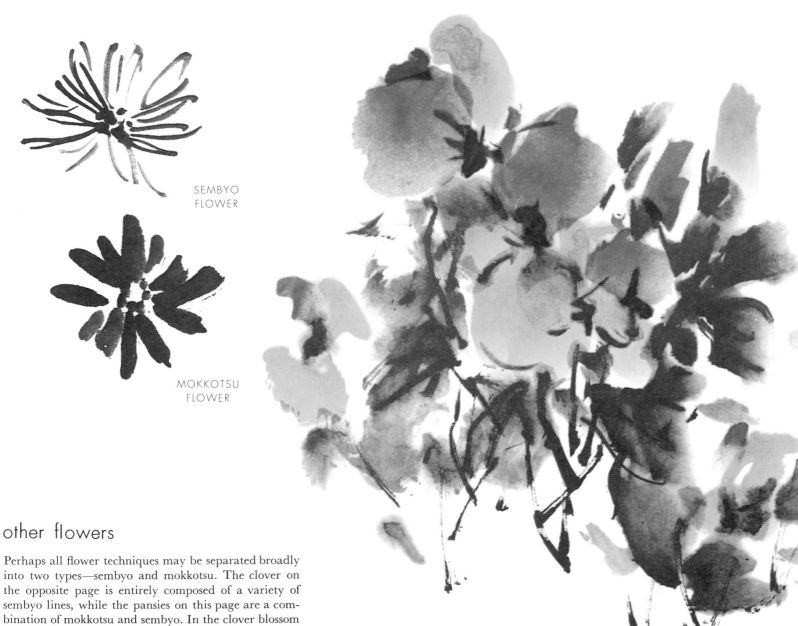

SEMBYO
FLOWER

MOKKOTSU
FLOWER

other flowers

Perhaps all flower techniques may be separated broadly into two types—sembyo and mokkotsu. The clover on the opposite page is entirely composed of a variety of sembyo lines, while the pansies on this page are a combination of mokkotsu and sembyo. In the clover blossom the techniques of the chrysanthemum are recognizable, but the strokes are shorter and more gently curved. Similar strokes are used for this entire family of flowers— daisies, asters, and all those of linear design. The foliage is done in grass techniques similar to those used for the wild orchid. The pansy, with its broad petals, stems from the plum-blossom technique, as also does the rose on page 31. There are many flowers which suggest this petal technique, such as the peony and the camellia. The leaves of the pansy are similar in technique to those of the chrysanthemum.

Once one is familiar with all the techniques of the "four gentlemen"—orchid, bamboo, plum, and chrysanthemum—it will be evident that almost any flower is similar in whole or in part to one or more of these basic strokes.

33

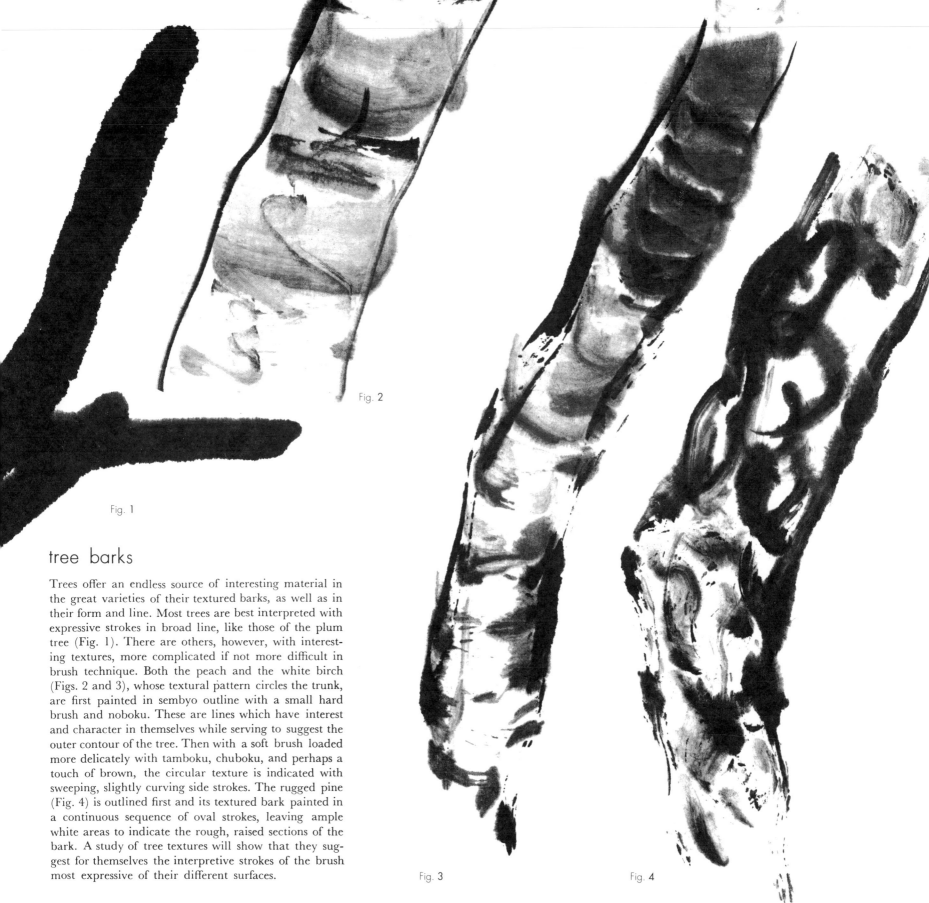

Fig. 2

Fig. 1

tree barks

Trees offer an endless source of interesting material in
the great varieties of their textured barks, as well as in
their form and line. Most trees are best interpreted with
expressive strokes in broad line, like those of the plum
tree (Fig. 1). There are others, however, with interest-
ing textures, more complicated if not more difficult in
brush technique. Both the peach and the white birch
(Figs. 2 and 3), whose textural pattern circles the trunk,
are first painted in sembyo outline with a small hard
brush and noboku. These are lines which have interest
and character in themselves while serving to suggest the
outer contour of the tree. Then with a soft brush loaded
more delicately with tamboku, chuboku, and perhaps a
touch of brown, the circular texture is indicated with
sweeping, slightly curving side strokes. The rugged pine
(Fig. 4) is outlined first and its textured bark painted in
a continuous sequence of oval strokes, leaving ample
white areas to indicate the rough, raised sections of the
bark. A study of tree textures will show that they sug-
gest for themselves the interpretive strokes of the brush
most expressive of their different surfaces.

Fig. 3

Fig. 4

34

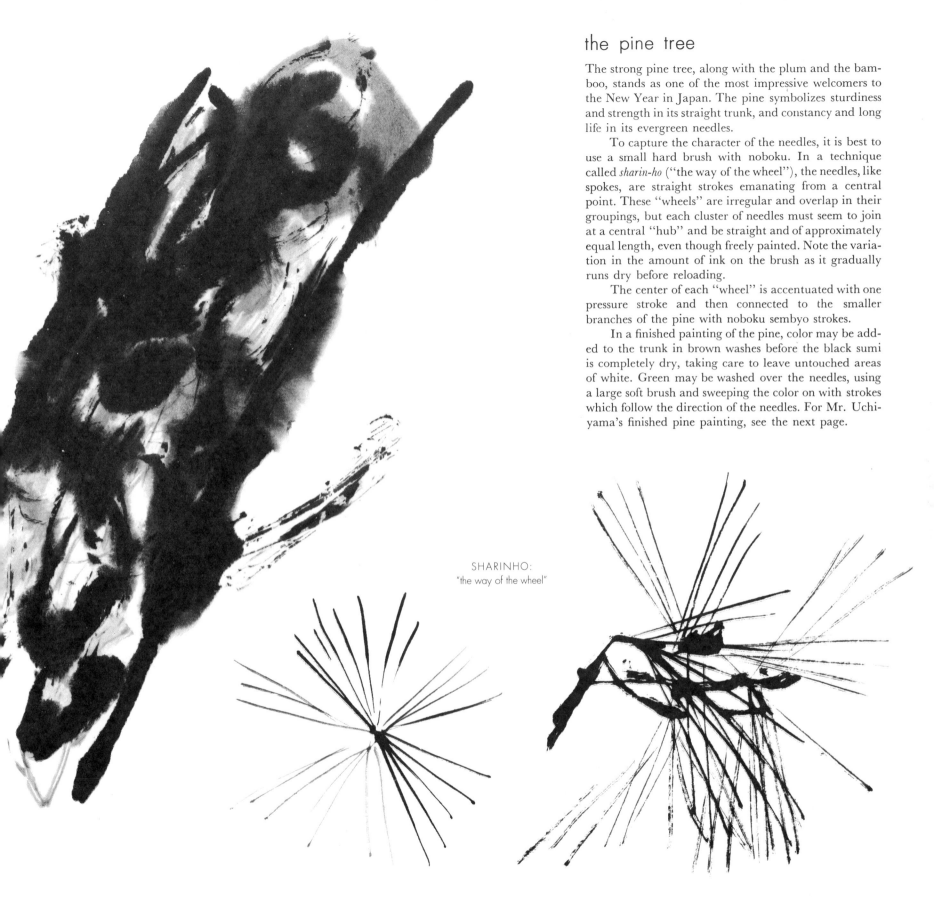

the pine tree

The strong pine tree, along with the plum and the bamboo, stands as one of the most impressive welcomers to the New Year in Japan. The pine symbolizes sturdiness and strength in its straight trunk, and constancy and long life in its evergreen needles.

To capture the character of the needles, it is best to use a small hard brush with noboku. In a technique called *sharin-ho* ("the way of the wheel"), the needles, like spokes, are straight strokes emanating from a central point. These "wheels" are irregular and overlap in their groupings, but each cluster of needles must seem to join at a central "hub" and be straight and of approximately equal length, even though freely painted. Note the variation in the amount of ink on the brush as it gradually runs dry before reloading.

The center of each "wheel" is accentuated with one pressure stroke and then connected to the smaller branches of the pine with noboku sembyo strokes.

In a finished painting of the pine, color may be added to the trunk in brown washes before the black sumi is completely dry, taking care to leave untouched areas of white. Green may be washed over the needles, using a large soft brush and sweeping the color on with strokes which follow the direction of the needles. For Mr. Uchiyama's finished pine painting, see the next page.

SHARINHO:
"the way of the wheel"

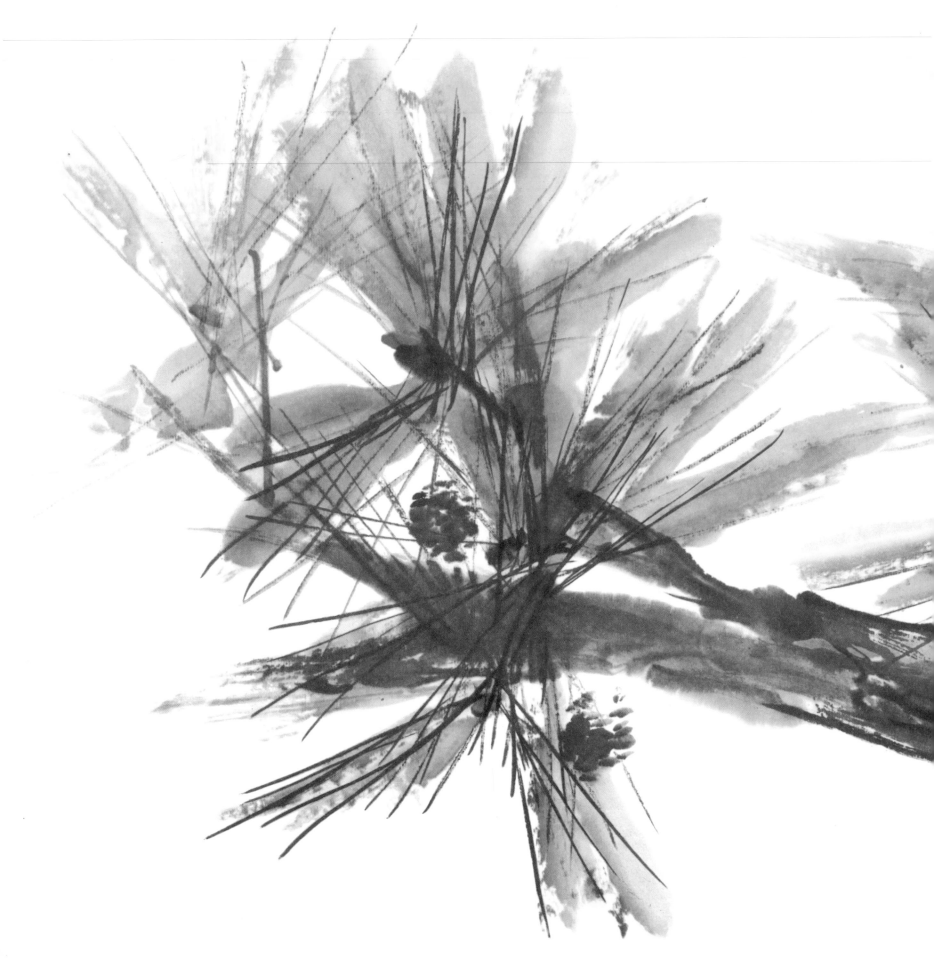

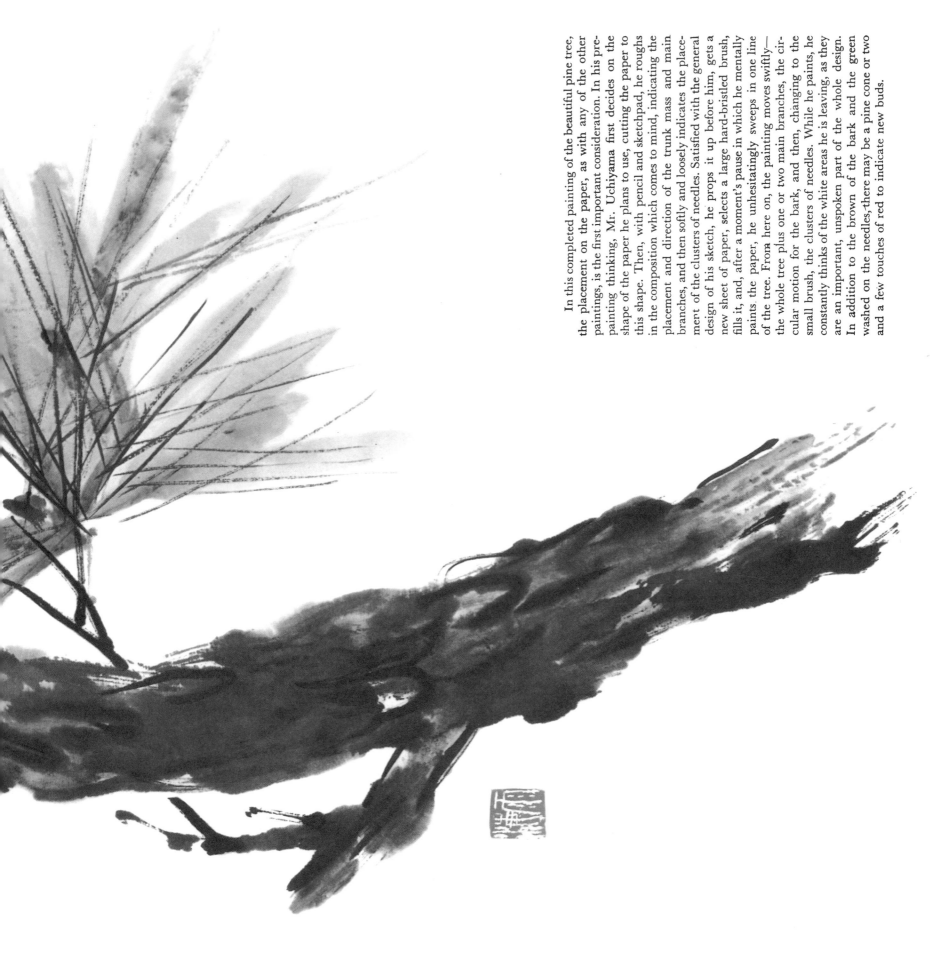

In this completed painting of the beautiful pine tree, the placement on the paper, as with any of the other paintings, is the first important consideration. In his pre-painting thinking, Mr. Uchiyama first decides on the shape of the paper he plans to use, cutting the paper to this shape. Then, with pencil and sketchpad, he roughs in the composition which comes to mind, indicating the placement and direction of the trunk mass and main branches, and then softly and loosely indicates the place-ment of the clusters of needles. Satisfied with the general design of his sketch, he props it up before him, gets a new sheet of paper, selects a large hard-bristled brush, fills it, and, after a moment's pause in which he mentally paints the paper, he unhesitatingly sweeps in one line of the tree. From here on, the painting moves swiftly—the whole tree plus one or two main branches, the cir-cular motion for the bark, and then, changing to the small brush, the clusters of needles. While he paints, he constantly thinks of the white areas he is leaving, as they are an important, unspoken part of the whole design. In addition to the brown of the bark and the green washed on the needles, there may be a pine cone or two and a few touches of red to indicate new buds.

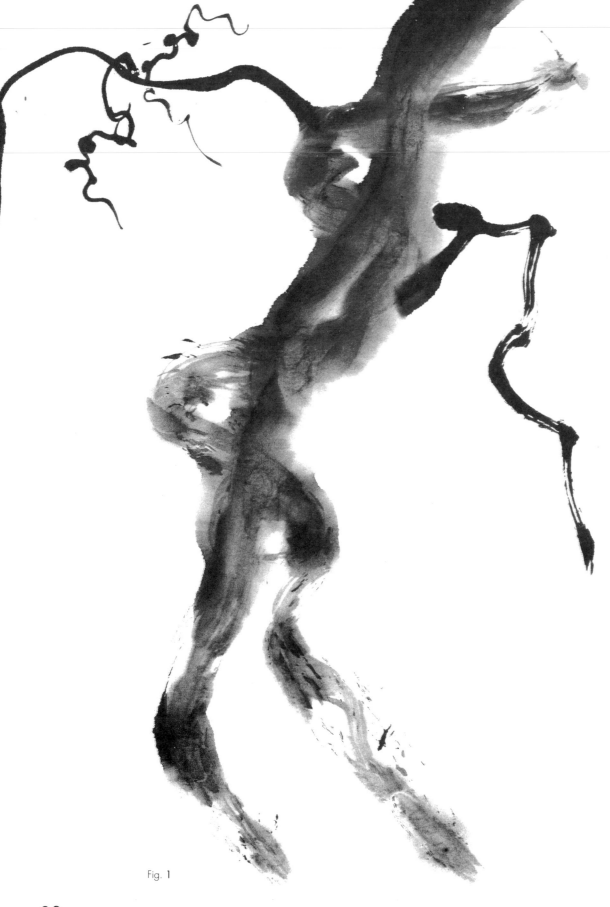

Fig. 1

fuji, the wisteria

Wisteria takes pride in its twisted contours: the more aged and entwined it is, the more venerated the vine. Always, too, the aged wisteria vine affords linear contrasts with its curly new tendrils, which each year become more twisted. The wisteria with white or purple blossoms in full bloom is very beautiful, but is also an interesting sumi subject in the late autumn when the flower turns to pods, dried and brown.

The vine (Fig. 1) is painted with a large soft brush dipped on one side in tamboku and on the other in noboku. With a fluent motion of the brush, held on its side mokkotsu style, the twisting of the vine is felt while the brush is directed in turns and curves on the paper. While the heavy vine is still damp, change to a small hard brush and noboku and paint the young tendrils like quick threads leading from the vine, twisting and changing the direction of the brush. These new little shoots are curly and springy, accentuating the aged solidity of the main vine.

The structure of the foliage, as shown in Fig. 2, is a series of oval leaves, graduating in size, attached to a sweeping main stem. The stem is a noboku line while the leaves are painted with a soft brush filled with tamboku and noboku. Each leaf is one stroke, with more pressure in the middle of the stroke to form the widest part of the leaf. These strokes are directed away from the stem line on either side. Usually, for the sake of interest, one side will be more clearly defined than the other. Since all foliage on any tree or plant is rarely in the same condition of growth, make good use of this natural design by duplicating the variety in twisting some stems and barely indicating some of the leaves.

For the cluster of blossoms (Fig. 3), use a soft brush filled with black, or with rich tones of purple as shown here. Keeping the richest tones of the newly loaded brush in the heaviest part of the cluster, begin the blossoms with two side strokes close together. Repeating these two strokes, build the cluster of blossoms downward and, as the paint weakens on the brush, work towards the edges, being careful not to form too even an outline of the flower mass and becoming freer in technique at the same time. Thus, as the blossoms become smaller, they become less well defined and paler in tone. Reaching the lower tip of the cluster, another brush is selected, this time a small one dipped in the richest tone of purple or black, and used to touch in the unopened buds with quick pressure strokes, unevenly placed and tapering toward the very tip.

The stem is now added with noboku and a hard brush, beginning from the top and continuing in broken sections which follow the graceful line of the blossoms. Little stems branch off the main stem to support, or appear to support, the flowers and buds.

For a completed wisteria painting, see the next page.

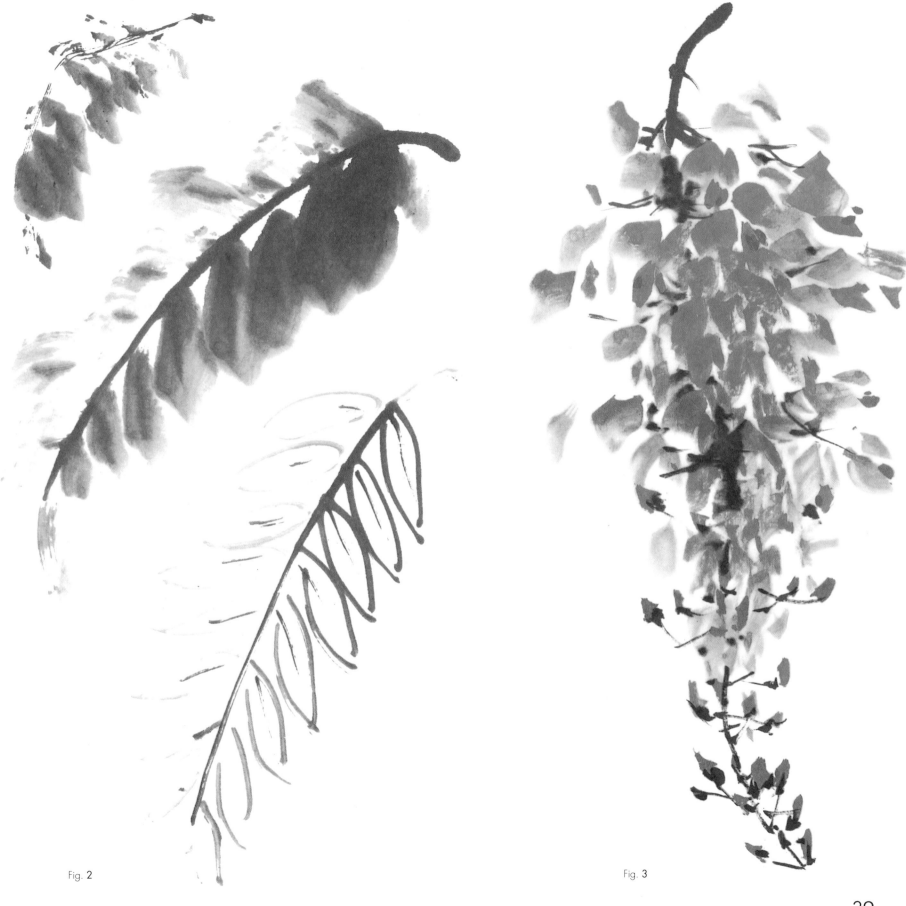

Fig. 2

Fig. 3

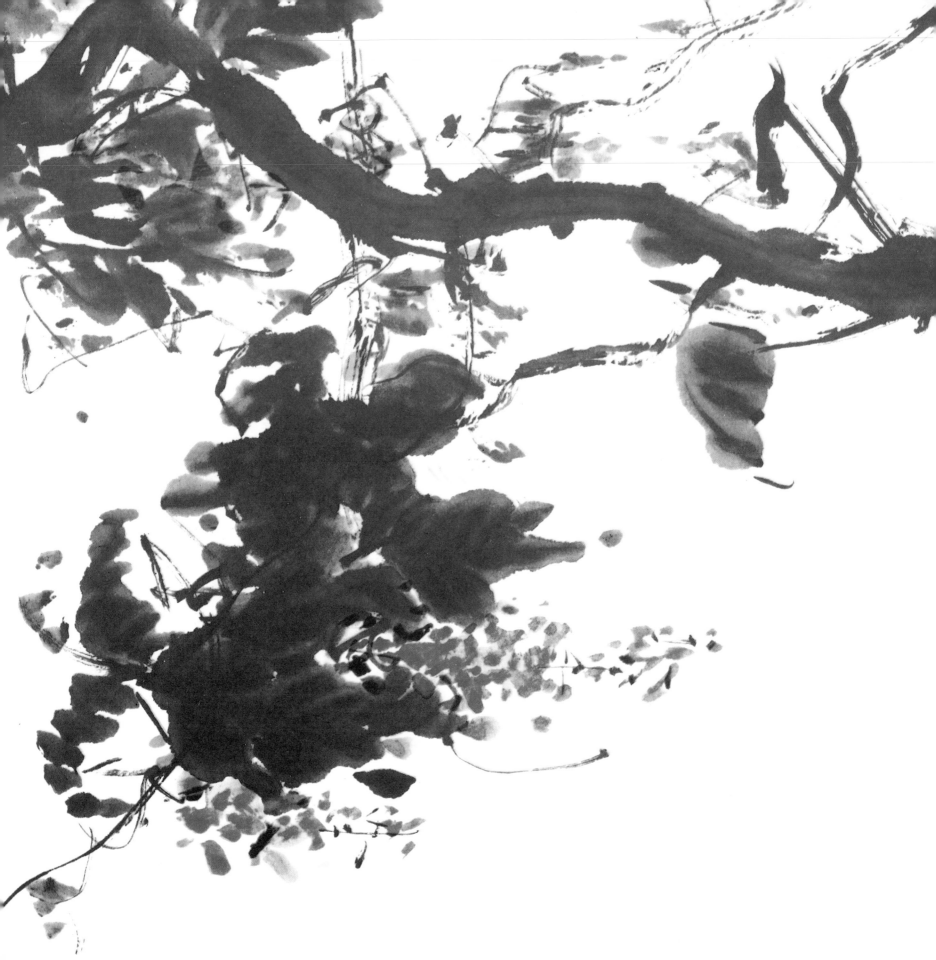

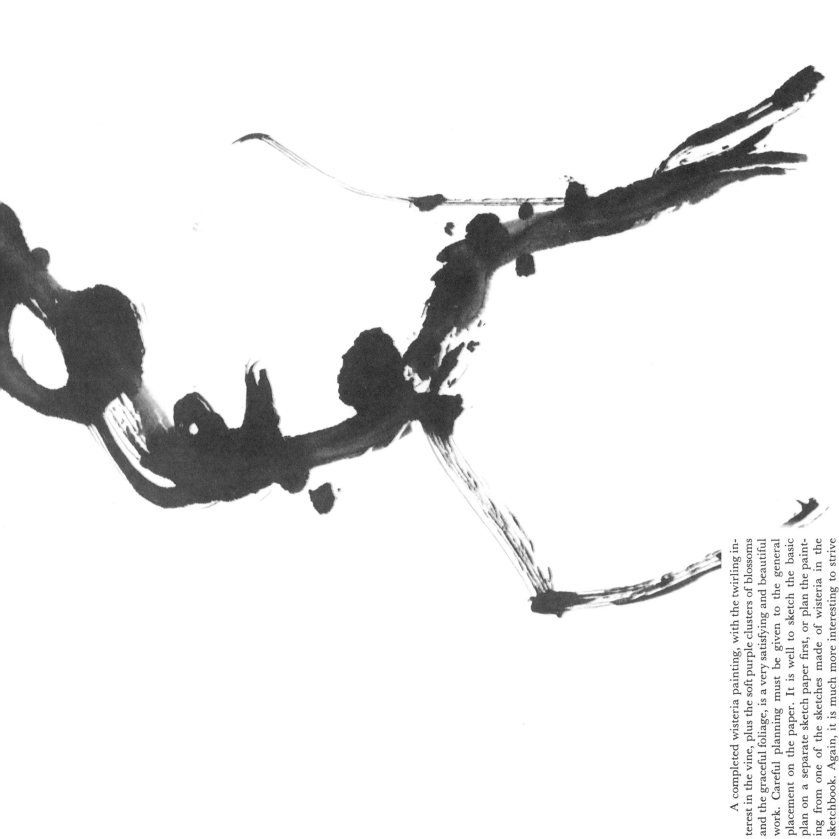

A completed wisteria painting, with the twirling interest in the vine, plus the soft purple clusters of blossoms and the graceful foliage, is a very satisfying and beautiful work. Careful planning must be given to the general placement on the paper. It is well to sketch the basic plan on a separate sketch paper first, or plan the painting from one of the sketches made of wisteria in the sketchbook. Again, it is much more interesting to strive for an asymmetrical balance on the paper rather than to center the subject matter. Keep groupings of flowers and leaves together in interesting counterbalance with the vine area and white paper.

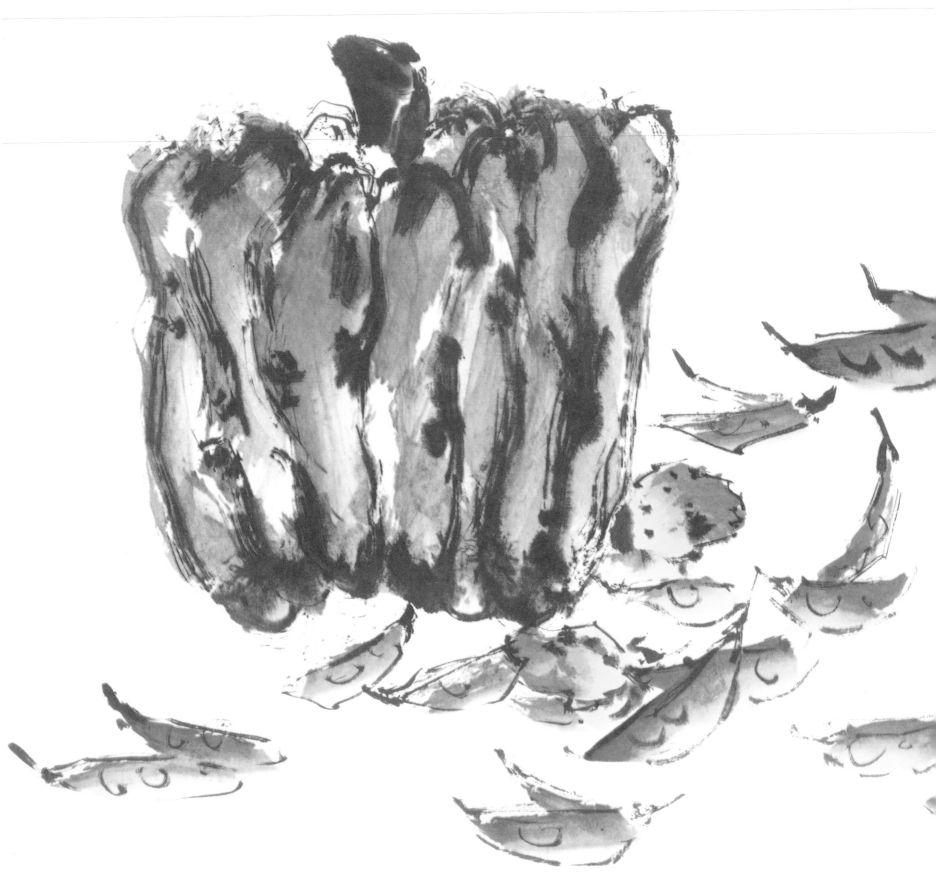

fruits and vegetables

Interpreting the variety of textures and contours evident in the fruit and vegetable world can be a challenge to the brush dexterity of any artist. For sumi-e it is again a matter of studying these surfaces and contours to achieve the most simplified stroke that will best express the subject.

The strawberry is painted with a large hard-bristled brush, dipped in yellow on one side and red on the tip of the other. The brush is pressed to the paper in such a way that the two colors contact the paper simultaneously but then the base of the bristles, or yellow section, is slightly pivoted to round out the broader, unripened part of the berry. With a small brush dipped in noboku, indicate the uneven sembyo outline, the stem, and a few free texture dots in the red area of the berry.

The large, pumpkin-like squash requires a large brush. With the brush on its side, begin at the top and push the bristles up, until with a twist, the stroke turns back on itself and on down, seeking to express the interesting contour as it curves in and out. The base of the squash repeats the twist of the top in reverse. Each section

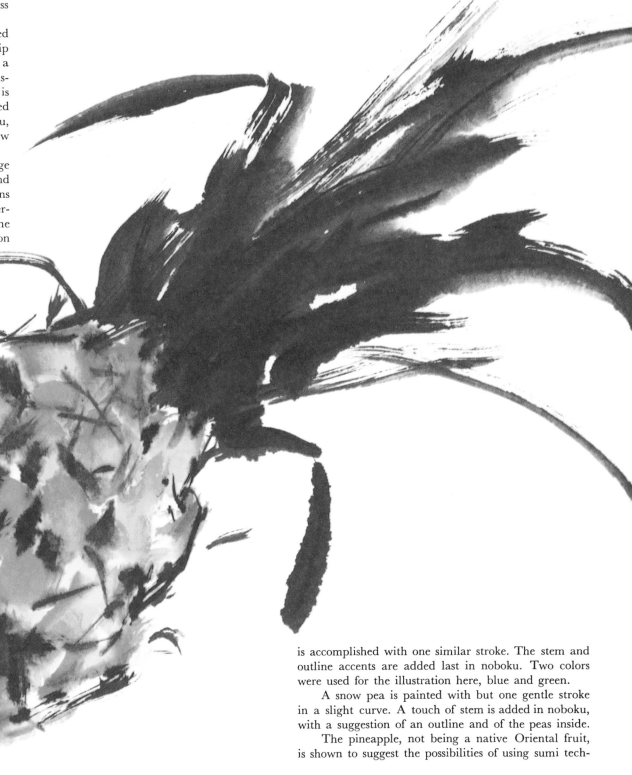

is accomplished with one similar stroke. The stem and outline accents are added last in noboku. Two colors were used for the illustration here, blue and green.

A snow pea is painted with but one gentle stroke in a slight curve. A touch of stem is added in noboku, with a suggestion of an outline and of the peas inside.

The pineapple, not being a native Oriental fruit, is shown to suggest the possibilities of using sumi tech-

niques for fruits and vegetables of other parts of the world. This fruit has a chopped and angular surface which suggests that the brush, being loaded with yellow, red, and perhaps a touch of green on different sides, be pressed to the paper in straight, short side-strokes at angles to each other. Keeping the richest color in the central area of the fruit, the strokes and the color both become less clearly defined toward the outer edges. Accents of noboku may be added in the same straight and angular manner, while the stem or leaves of the fruit will be recognized as variation of the grass technique.

Since many fruits give the appearance of being round, the grape technique is a basic one. Oranges, cherries, and loquats, to mention a few, are handled in a similar manner. For the grape, use a soft, medium-size brush and load it on either side with two tones of black, purple, or perhaps green. Hold the brush upright and press the point to the paper so that the richest tone is the center of the fruit. Then lower the length of the bristles, turning the brush at the same time in a pivot around the tip of the brush, to form in one circular stroke the form of the fruit. Repeat this stroke to create a cluster of grapes, working toward the outer edges of the cluster as the paint is used up. Reload as often as needed, remembering to keep the richest color toward the center where the bulk of the grapes are hanging. Lastly, the stem is added with a small hard brush and noboku.

Eggplants, some of which are quite small in Japan and are attached to a long, twisted stem, make a very interesting contour for sumi-e. A similar shape might be that of the cucumber, summer squash, or zucchini. A large soft brush is loaded generously with chuboku and noboku (or two tones of purple if using color), the deepest tone, as usual, at the tip. This tip, unlike that of the grape technique, forms the outer edge of the vegetable in one curving stroke, while the paler tone at the base of the bristles becomes the rounded center. The stroke leads

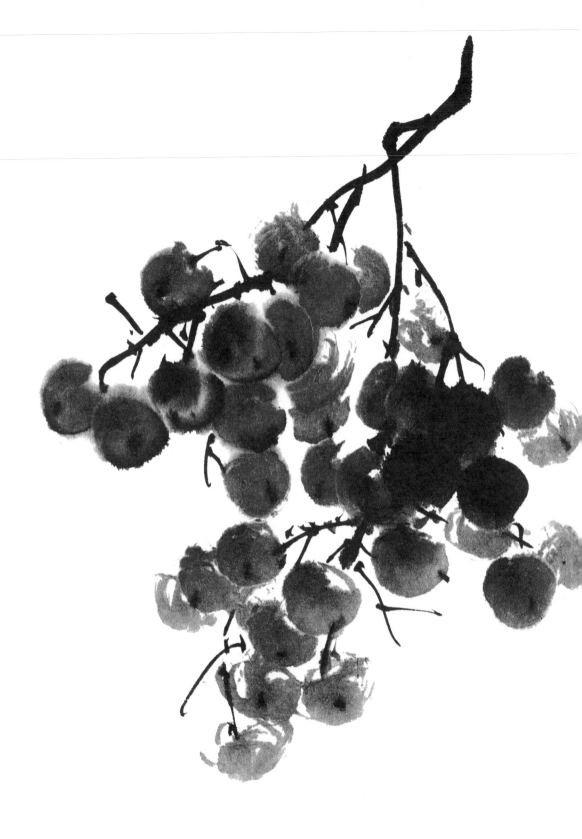

44

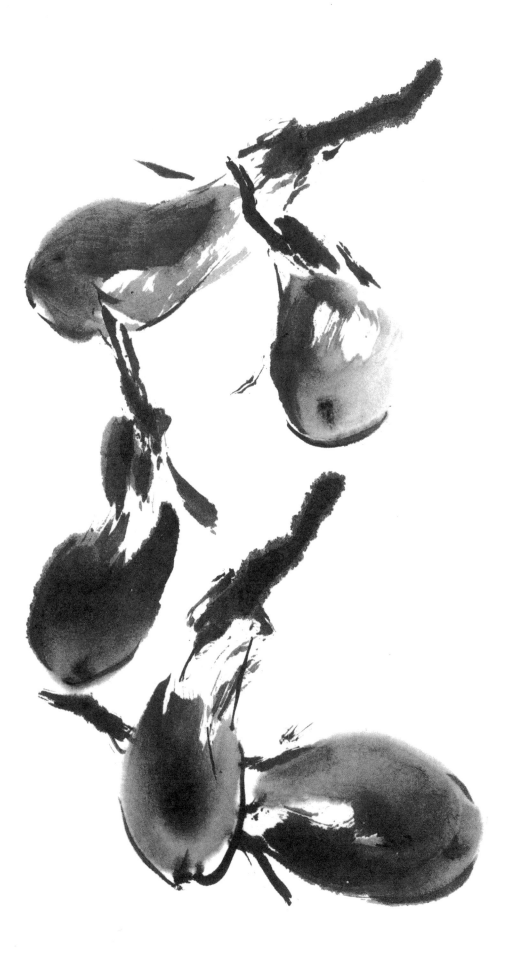

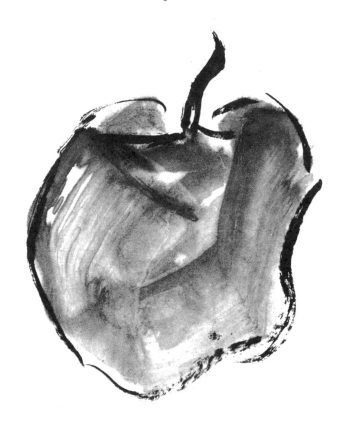

out from an inner curve, turning on itself to form the other outer edge. Leaving some white space between, and changing to a hard brush and noboku, paint the stem with quick, sure strokes that will complement the soft curves of the vegetable.

The technique of the apple shown here, similar to that of the pear, may also be likened to the rock technique to be seen on a later page. It is composed of planes—three, sometimes four. It is not round like the orange or grape and its concave-convex contour must be painted with a feeling for this contrasting volume. Use a large hard brush loaded with two tones and with a side sweep of the brush paint the main mass of the fruit as you see it. In this case it was the left side, painted with a downward stroke. The brush was lifted briefly, stroked across the top center of the apple, leaving white space where the stem would be. Picking up the right side, then, the stroke changes direction, forming contrasting contours to those of its opposite side.

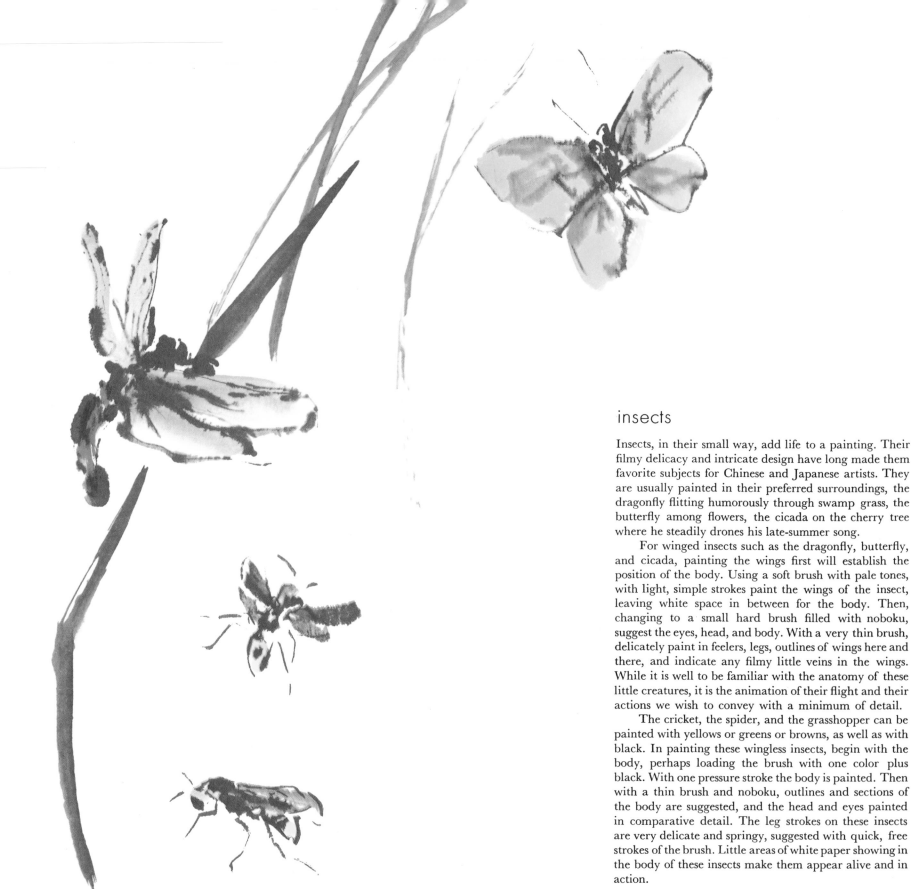

insects

Insects, in their small way, add life to a painting. Their filmy delicacy and intricate design have long made them favorite subjects for Chinese and Japanese artists. They are usually painted in their preferred surroundings, the dragonfly flitting humorously through swamp grass, the butterfly among flowers, the cicada on the cherry tree where he steadily drones his late-summer song.

For winged insects such as the dragonfly, butterfly, and cicada, painting the wings first will establish the position of the body. Using a soft brush with pale tones, with light, simple strokes paint the wings of the insect, leaving white space in between for the body. Then, changing to a small hard brush filled with noboku, suggest the eyes, head, and body. With a very thin brush, delicately paint in feelers, legs, outlines of wings here and there, and indicate any filmy little veins in the wings. While it is well to be familiar with the anatomy of these little creatures, it is the animation of their flight and their actions we wish to convey with a minimum of detail.

The cricket, the spider, and the grasshopper can be painted with yellows or greens or browns, as well as with black. In painting these wingless insects, begin with the body, perhaps loading the brush with one color plus black. With one pressure stroke the body is painted. Then with a thin brush and noboku, outlines and sections of the body are suggested, and the head and eyes painted in comparative detail. The leg strokes on these insects are very delicate and springy, suggested with quick, free strokes of the brush. Little areas of white paper showing in the body of these insects make them appear alive and in action.

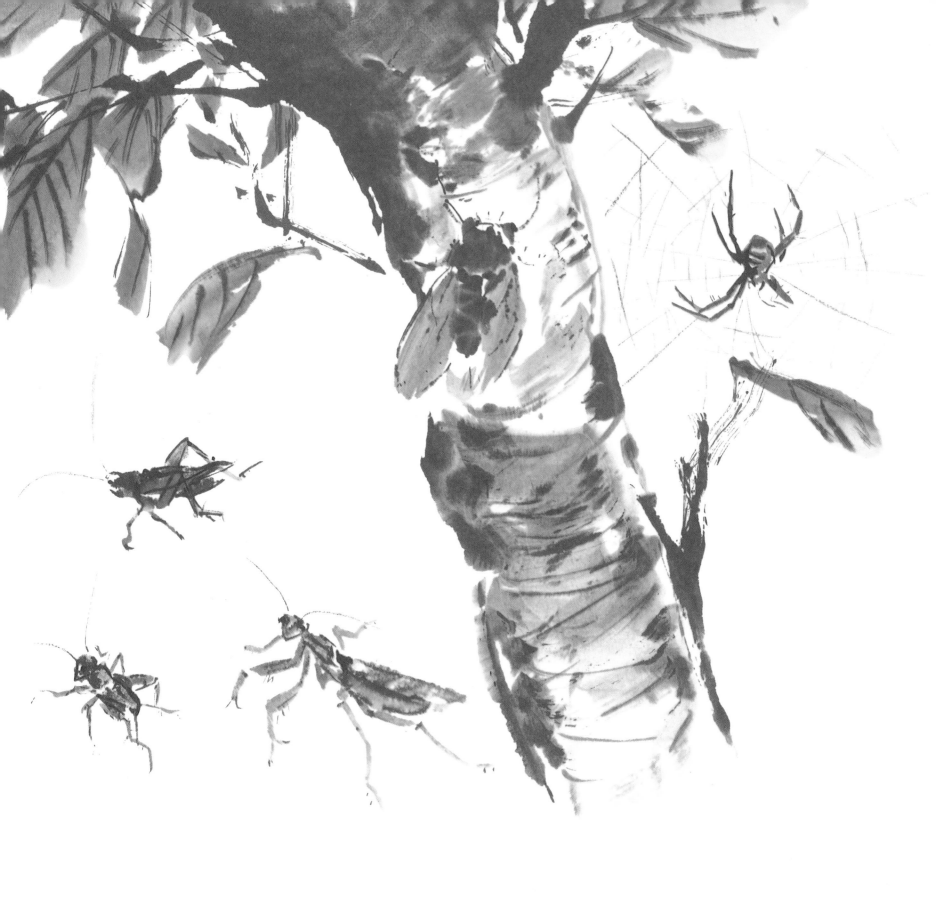

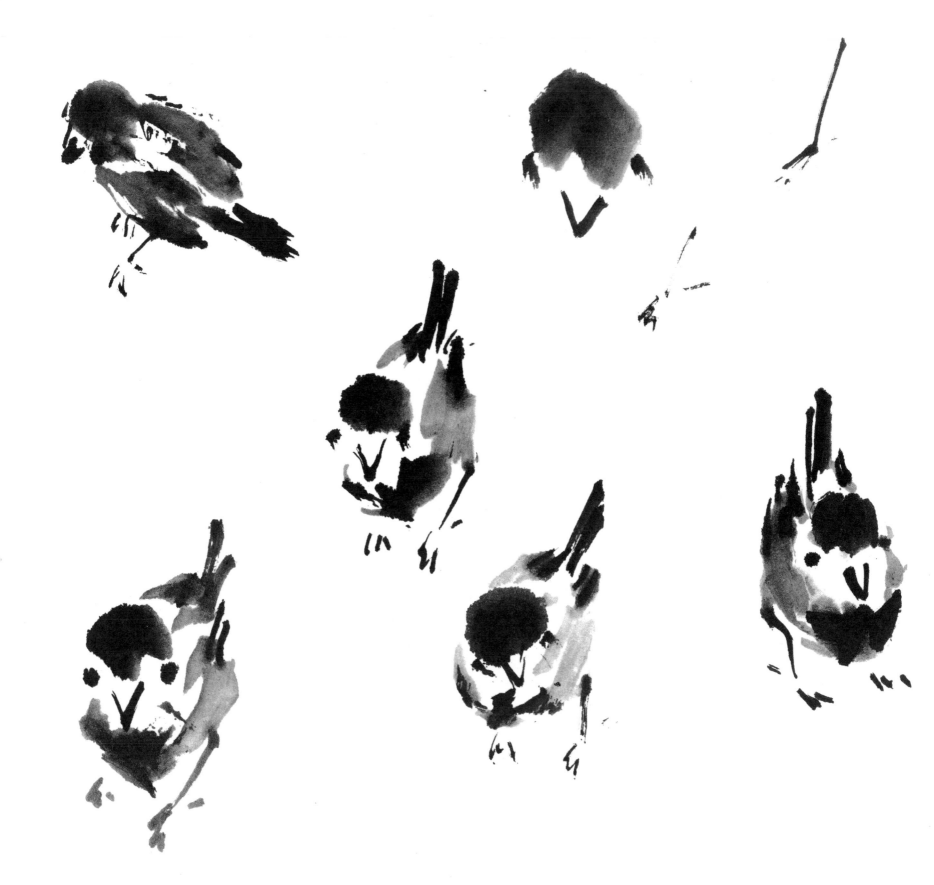

birds: the sparrow

The little brown sparrow adds a bit of animation to many an Oriental painting. Huddled on a snowy pine branch or content among the bamboo, it contributes to seasonal atmosphere by adding warmth and life. Since in sumi painting we wish mainly to catch the bird's animated spirit, we do not paint it in great detail, but knowing its construction through observation, we attempt to indicate the quick movements of the little body through the strokes of the brush.

Start with a small, soft brush dipped on alternate sides in the middle and the darkest tones with perhaps a touch of brown. With two wash strokes, side by side, paint the top of the bird's head. Change to a small hard brush dipped in noboku and with two sembyo strokes paint the beak to establish the tilt of the bird's head. While the eyes are two quick daubs of the brush, their intentional irregularities serve to give the bird its spirit and personality and add to the quick, fleeting appearance.

After establishing the position of the head, the twist of the body is determined first of all by the placement and the direction of the chest bone. The small hard brush is loaded with middle and dark tones of sumi. The chest bone is one pressure stroke of the dark side of the brush, followed on either side, with broad strokes directed away from the chest bone. Each of these strokes will differ in size depending on the angle of the bird's body. Building from this, with a soft brush and chuboku and tamboku, paint the soft feathers covering the body in upward strokes which taper towards the tail. Tips of the body feathers are accented with touches of noboku.

The tail feathers are composed of two strong downward strokes, essentially straight and close together yet separated by a bit of white. This is a difficult skill requiring practiced control of the brush.

When painting the delicate feet of a little bird such as the sparrow, bear in mind that, unlike larger birds and fowl who walk and swim, these are hopping birds, and the little claws are close together and appear fragile. They need not be painted in great detail, but quite freely sketched in after their position has been decided upon.

It will be evident to the artist that putting all these strokes together will require not only some structural knowledge of the bird, but also a familiarity with its motions and habits. Store up mental pictures continually when observing birds—the tilt of the head, the position of the feet and wings in flight. The fleeting motions of birds are truly compatible with ink painting.

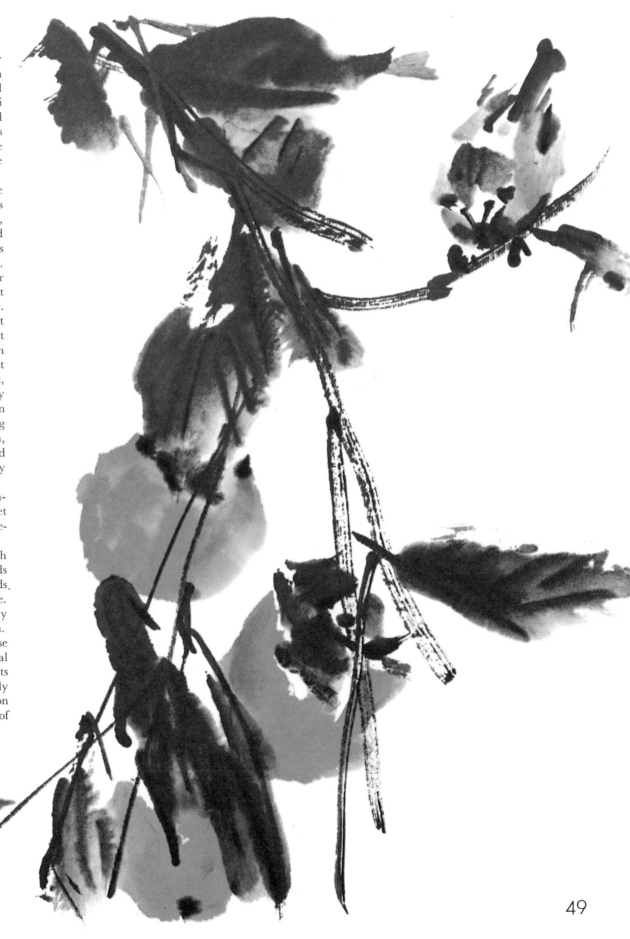

49

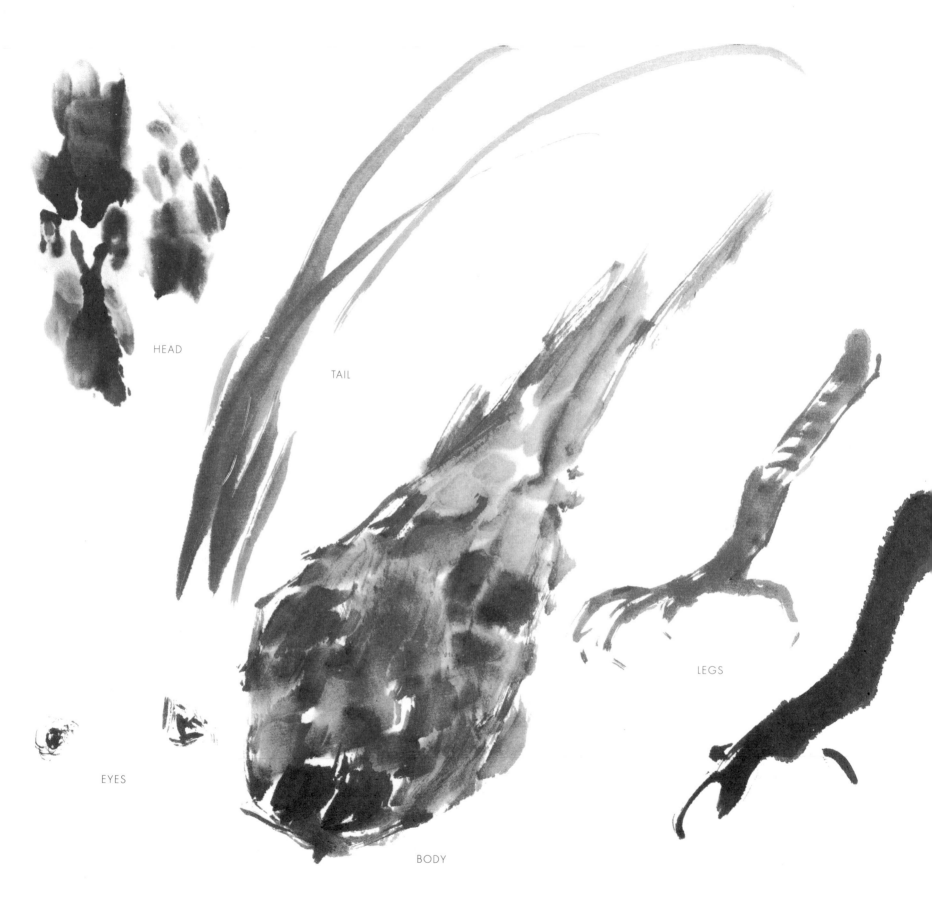

HEAD

TAIL

LEGS

EYES

BODY

50

larger birds

Using a small hard brush and noboku, begin with the eyes by painting an irregular dot for the eyeball, surrounding this with a few short straight strokes, being sure to leave a touch of white. Follow the eyes with a swift "v" stroke for the beak. Having established the tilt of the head, commence building the head, bringing out any telling characteristics of the bird. The feathers on the body are built upon each other in a series of strokes which follow the contour, suggesting the solid form underneath. Retain the deeper tones of sumi for the heavier part of the bird, while keeping outer edges paler and softer. The tones also become deeper and darker towards the tail. Before the feather strokes are entirely dry, add noboku touches for accent.

The feet, if shown, are painted quickly in noboku. They identify the position of the bird and add a rugged contrast to the soft plumage.

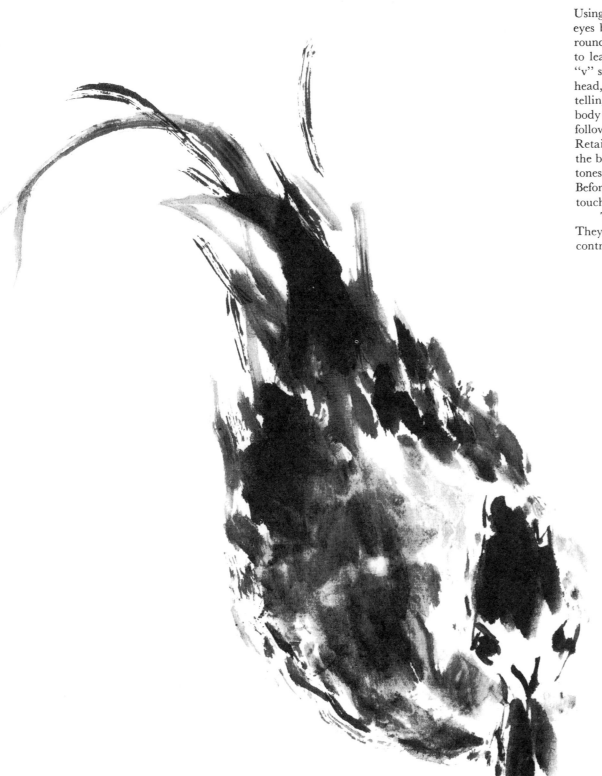

fish

Fish lend themselves almost naturally to sumi's active brush strokes and flowing lines. The goldfish below appear to be alive and swimming in the water of the white paper. With a soft brush, using either black or color, paint the head and body in one pressure stroke, curving it to suggest the shape of the fish. Two or three expressive strokes suggest the floating tail and fins. Black touches make the eyes and provide outline and accent where they are felt to be needed.

As with all living creatures, it is the eye which gives expression and humor. The first stroke of the squid at right is the black of the eye. Leaving white space and using a large soft brush, the head is painted with long flowing strokes extending to form the tentacles. The body strokes are washed in freely and before the paint is quite dry accents and contour lines are painted with a small brush and noboku.

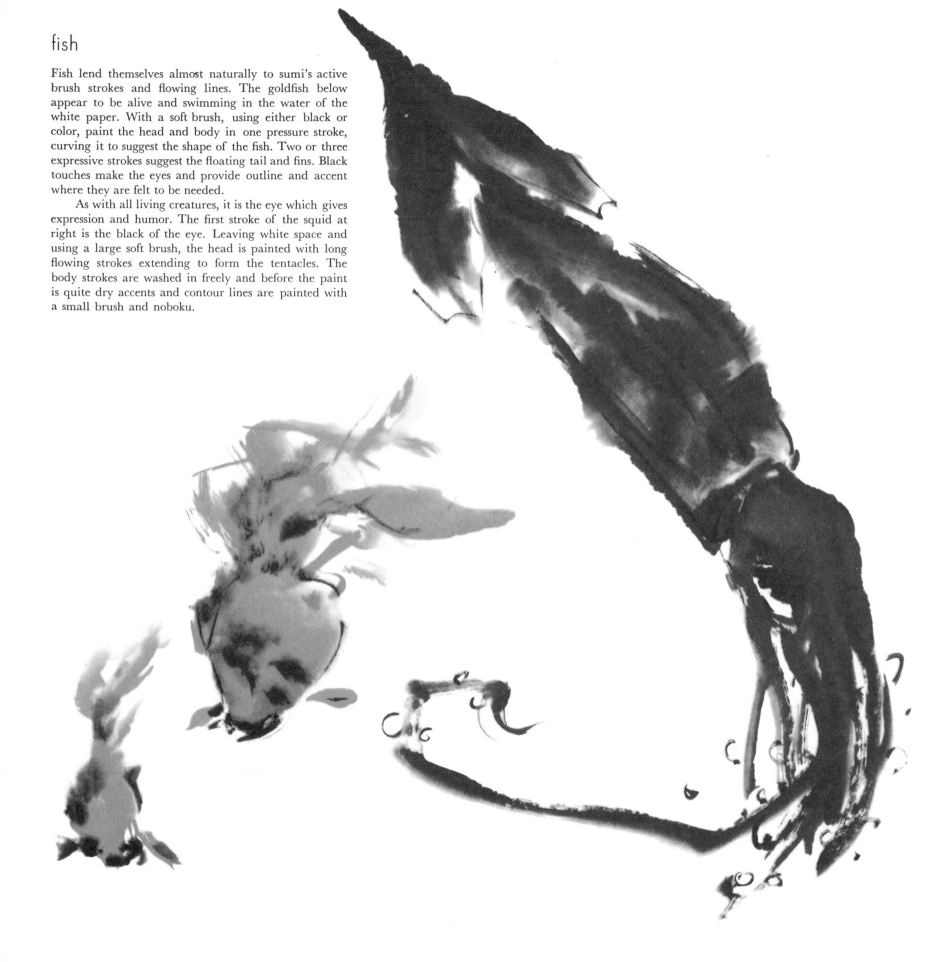

While the goldfish and squid are done in flowing shapes of tone, some creatures require more definitive "drawing" techniques. For example, in the clam shells here, lines and tone have been combined in two different ways to suggest the contours. For the largest shell, the sumi outline was drawn first and the color tones added afterwards. For the two smaller shells, the color was swirled on the paper so as to suggest the shape almost completely in one curving brush stroke and then the sembyo lines and black accents were added.

The fish below is a combination of wash and line techniques alternating as the painting progresses. Beginning with the eye, as usual, work in wash strokes which "feel" the indentations of the head, the broken curve of the gills. Then almost immediately, accent the most telling points with noboku line. All the lines are painted with a small hard brush and noboku, while the tone or color is painted with a large soft brush. Paint quickly while closely observing the subject, curving and breaking the strokes as the contour changes. The tail helps the fish swim on the paper—it is almost "carelessly" suggested in two swift strokes as if quickly viewed in action. The body is painted with slightly rolling sidestrokes of the brush. Before this is dry, suggest scales and shimmering texture with a pattern of irregular brush touches and lines.

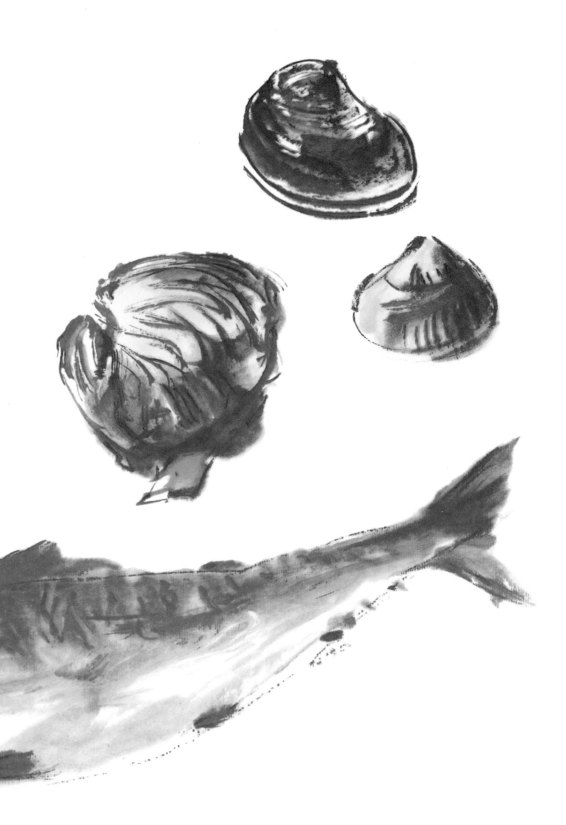

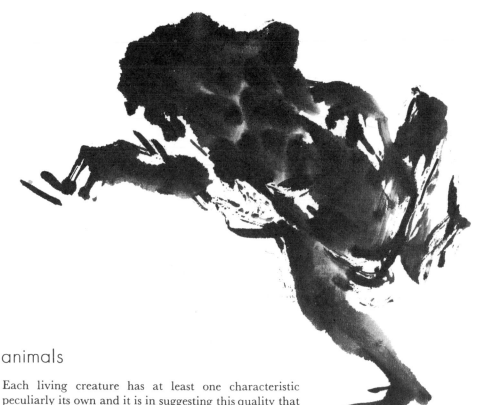

animals

Each living creature has at least one characteristic peculiarly its own and it is in suggesting this quality that a sumi painting becomes more than an anatomical rendition. Careful observation and many pencil sketches are behind the finished painting which appears simply done with a few telling strokes.

The lumpy mass of the frog is painted with a large soft brush combining chuboku and noboku. With a smaller hard brush and noboku only, the under part of the body is sketchily outlined, leaving white areas to complement the dark mass. Legs are a few quick strokes of the brush which suggest the frog's action.

The impressive dignity of the emperor penguin and the lumbering hulk of the elephant are caught in succinct statements of the sumi brush. It is best that general rules be followed here, since so much depends on the type of animal and the imagination and accomplishment of the individual artist.

The eye, which is the focal point of personality, is usually the first touch of the brush. Visualizing the subject in full on the paper, indicate the main contour of the head in one or two mokkotsu strokes. This should establish the stance of the creature, after which the essential sweeping line of the body, usually the back line, can be expressed in the fewest strokes necessary. The animal itself will suggest whether these strokes be sembyo or mokkotsu. The elephant, with its area of mass, is best portrayed with the broad side-strokes of mokkotsu, while the penguin's protruding white chest suggests a linear outline. Any details, such as feet, wings, or ears, and any textural qualities will also suggest their own manner of interpretation. It is the intent of the sumi artist to capture the impression of the body, simplified through the brush to its essentials of line and mass.

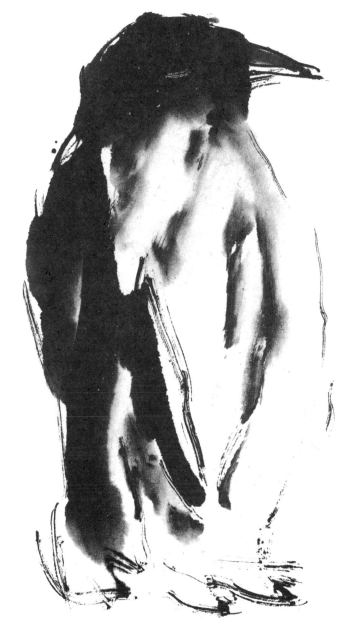

54

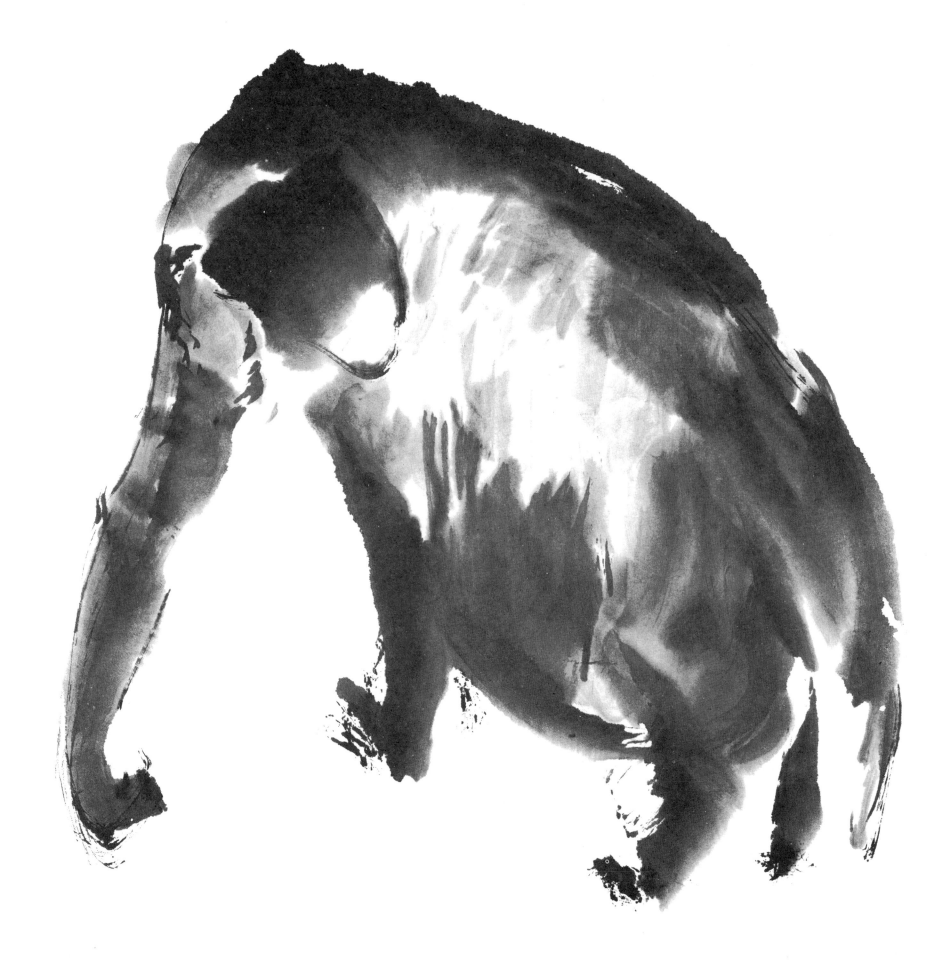

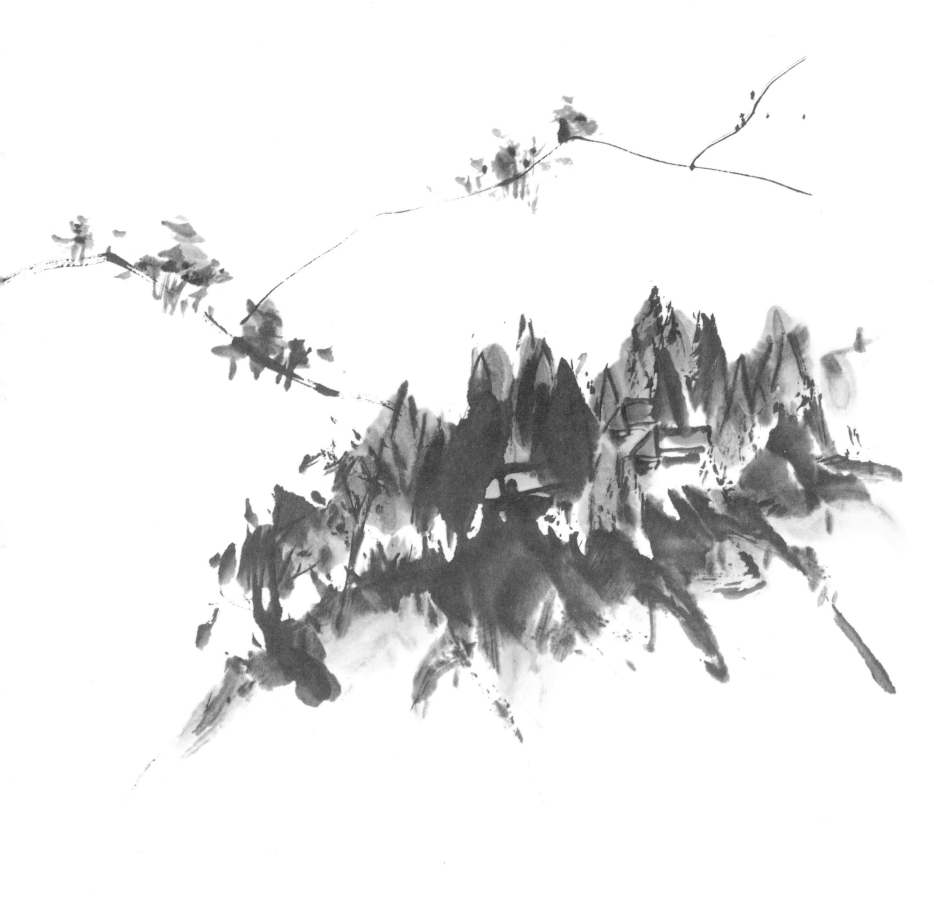

landscape . . . the sketchbook

Due to the nature of the tools used for sumi-e, the artist may find it impractical to paint directly out of doors; therefore the sketchbook becomes his constant companion, his source of inspiration and reference. He brings nature into his studio through the record of impressions he has seen and sketched on the scene. Landscape painting is bewildering to many awestruck admirers because the eye sees so much—so many trees, so many leaves, too many mountains perhaps, and greenery everywhere. The ability to select the point of interest in a given scene is difficult to the untrained eye, but is improved with observation and selective sketching. Invariably there is one area, one group of trees, one slope of a mountain, or some one thing to catch the eye. Feeling and instinct have as much to do with this selection as a visual knowledge of what is there. The center of interest need not be the most obvious object in sight. Whole mountains may be ignored and omitted entirely if they do not add to the sketch or painting. Everything in view is not needed as the wealth of beauty is there to serve the artist. Indeed one scene viewed and sketched from different points of interest may supply the inspiration for several paintings.

There has developed, through the centuries of Oriental painting, an extensive language of symbols, many of which are still evident in contemporary sumi painting. These symbols may be likened to chords in music—it is how they are combined that creates moving art. A knowledge of these symbols is an essential acquisition of the sumi artist. They are most helpful in quick, interpretive sketching.

On this page are some of the quick line "writings" which serve to indicate to the artist the mass of foreground trees, those at a middle distance, and those far away. The contour of a mountain or hill closely viewed is sketched in more rugged detail, while those further away are soft and rolling. Houses are mere outlines of shape and are a secondary part of the landscape. This particular sketch is in sumi, drawn with a stem of dried pampas grass instead of a brush, but a pencil sketch would have served equally well for the purpose of a "shorthand" record.

The painting on the facing page, using touches of color in the areas of greatest interest, is a brush interpretation of the original sketch shown here, losing none of its simplicity and freshness. The actual group of hills from which this painting was first sketched and then painted, is a vast green panorama on the coast of the Izu Peninsula. Only a few lines of hills on three different planes were selected along with the foreground tree area, making a beautifully simple commentary from a scene of limitless dimension. On the following pages are landscape techniques used both in sketching and in painting.

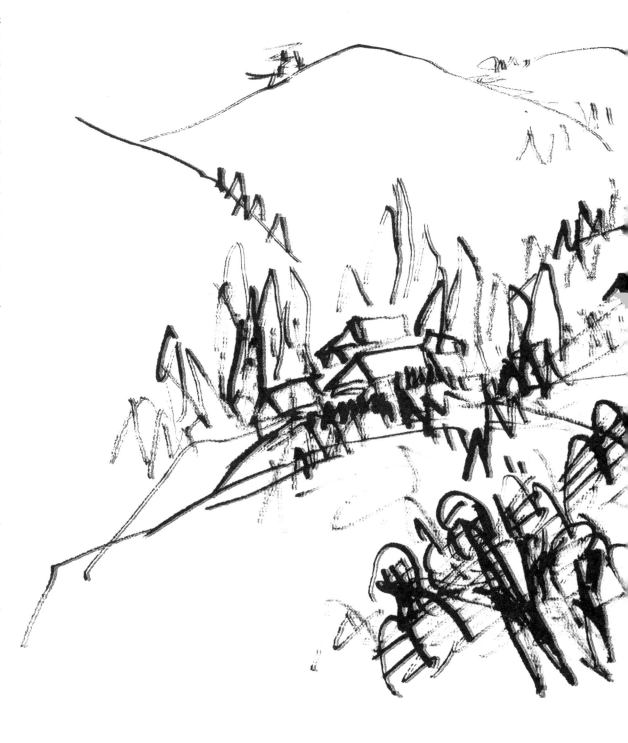

some landscape techniques

Cedars and pines abound in Japan. When they are painted, the degree of detail depends upon their proximity. Each tree above, fairly close to the observer, is painted with a strong downward sembyo stroke, followed by the addition of branches. Then, with a soft brush dipped in tamboku on one side and noboku on the other, foliage is painted with upward wash strokes which are rather flat at the bottom. Intermingle the tones, keeping darker, heavier branches toward the trunk and leaving sparkling areas of white "sky" between some of the foliage.

The crab-leg technique *(kaikyakuho)*—so called because of its resemblance to the angularly jointed sections of a crab's leg—is used to render the exposed roots of bamboo and various trees, as well as to suggest twigs and smaller branches. It is usually done with a small, hard brush and noboku. As with many other techniques of sumi-e, in a final painting these strokes may not be detected as such, but a familiarity with such accent strokes helps provide the interest which pleasurably accompanies the larger softer areas of moist sumi strokes.

Beiten or *chon-chon,* as these little dark touches of ink are called, seem to have no equally expressive word in English. In some ancient Chinese sumi-e these dots were used excessively, and upon visiting a museum or viewing reproductions of Oriental art, one will find many interesting uses of these mere touches of the brush. Added quickly to a still moist tree or vine, their blurring adds visual interest and design accent. Their placement is simply a matter of the artist's feeling . . . a touch here . . . a touch there. See also pages 26 and 27.

Branch forms, shown here in various groupings, are as endless in variety as are the strokes of the brush. All are combinations of the many types of sembyo line. Not always graceful and "pretty," these lines frequently are broken and angular. They must be strong, definite lines, conveying the feeling of the tree's growth in that the heavier section of the branch is at the base, gradually trailing off in thinner branches. Note here the use both of beiten and of a variation of hahogan (see pages 18–19) called *jojiho,* in which the three strokes are more straight than curved.

59

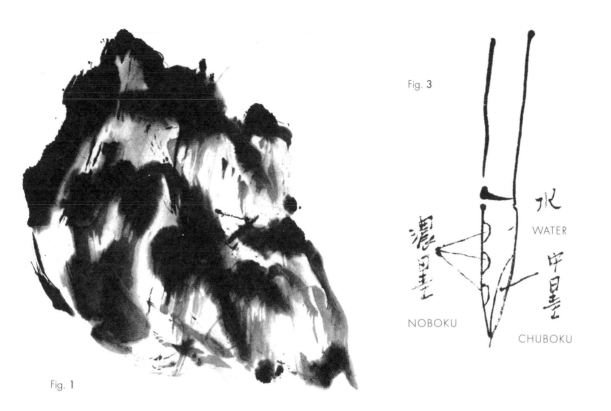

Fig. 1

Fig. 3

水
WATER

濃
墨
NOBOKU

中
墨
CHUBOKU

rocks

A rock painted in sumi technique must have at least three planes. Chinese artists used to refer to the delineation of such planes as "ax" strokes—big ax, little ax, etc. This accurately conveys the feeling of these jagged formations. Fig. 1 is similar to the traditional Chinese method. The brush, a hard-bristled one, is loaded with chuboku and noboku in the usual way. Paint the rock with broad side-strokes, breaking the surface into three or more planes and leaving white areas. Brush lightly over some of the white area with tamboku. Before this is dry, add noboku accents with a small hard brush, using the techniques of chon-chon and beiten as described on page 59.

Fig. 2 is a contemporary technique of Mr. Uchiyama's. The brush, a large, hard one, is loaded as in Fig. 3. The noboku dots are added to the large brush by means of a smaller one. With sweeping strokes delineate four planes, leaving some white highlight areas. After this is dry, noboku accents and outlines are added for sharpness.

Fig. 2

clouds

The soft swirling motions of floating clouds are painted with a large, soft brush. The brush is kept very moist and loaded with tamboku on one side and chuboku on the other. Holding the brush on its side, move the arm and hand in circular motions, changing directions now and then, varying the size of the circular shapes. There is a slight roll to the stroke as it curves on the paper. By leaving generous white areas the cloud formation will appear light and airy. The touch of the brush must be light and delicate at all times.

The *kappitsu* ("dry brush") stroke is one which is used to accent a cloud painting, particularly if the painting is to suggest imminent rain. After painting the pale circular strokes of the cloud and before the sumi dries, choose a smaller, hard-bristled brush touched in noboku and lightly follow the underneath sections of the larger circles, touching the brush briefly to the paper.

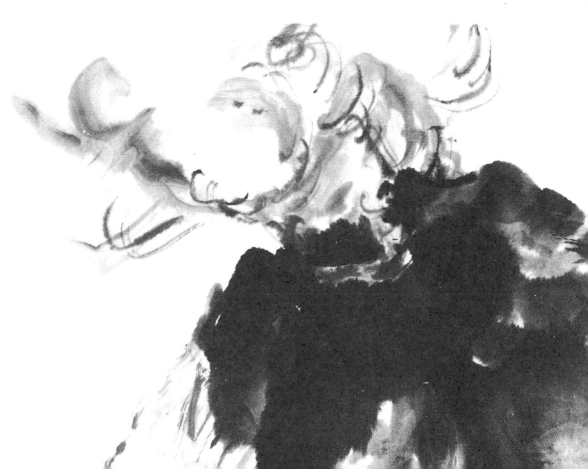

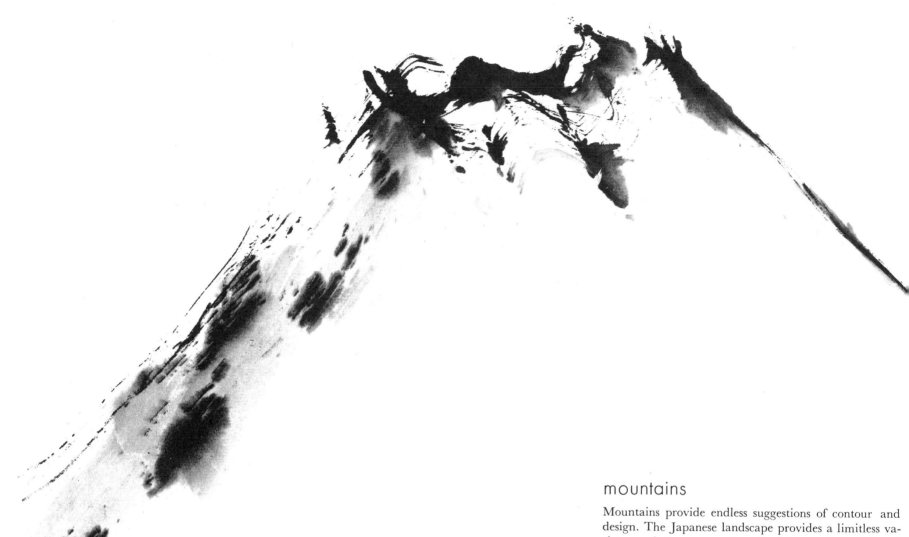

mountains

Mountains provide endless suggestions of contour and design. The Japanese landscape provides a limitless variety, and they are a favorite subject of all Oriental artists. Possessing individual personalities of their own, they may suggest monumental grandeur, rolling magnificence, or jagged strength. Varieties of mountains with accompanying landscape techniques will be seen on the following pages, but here are the strokes with which a sumi artist may suggest the famous Fujisan, beloved mountain of Japan.

The volcanic, irregular top is painted with a small, hard brush and noboku. The brush is held on its side and rolled at times while varying pressure is applied to it. Straight strokes pulled downward with the side of the brush express the mountain's sloping nature. Contrasting with these dark lines, a soft brush filled with tamboku indicates one side of the mountain in a broad sweeping stroke. Before the tamboku is dry, a small brush and noboku add interest to this pale side with touches of kappitsu as described for clouds on the preceding page.

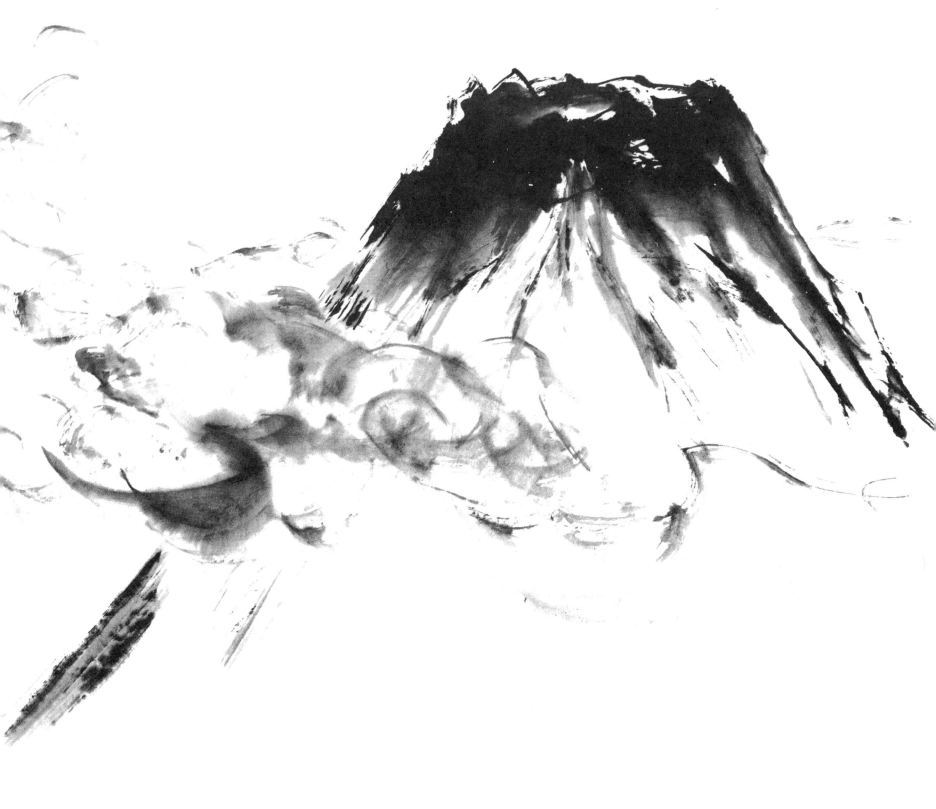

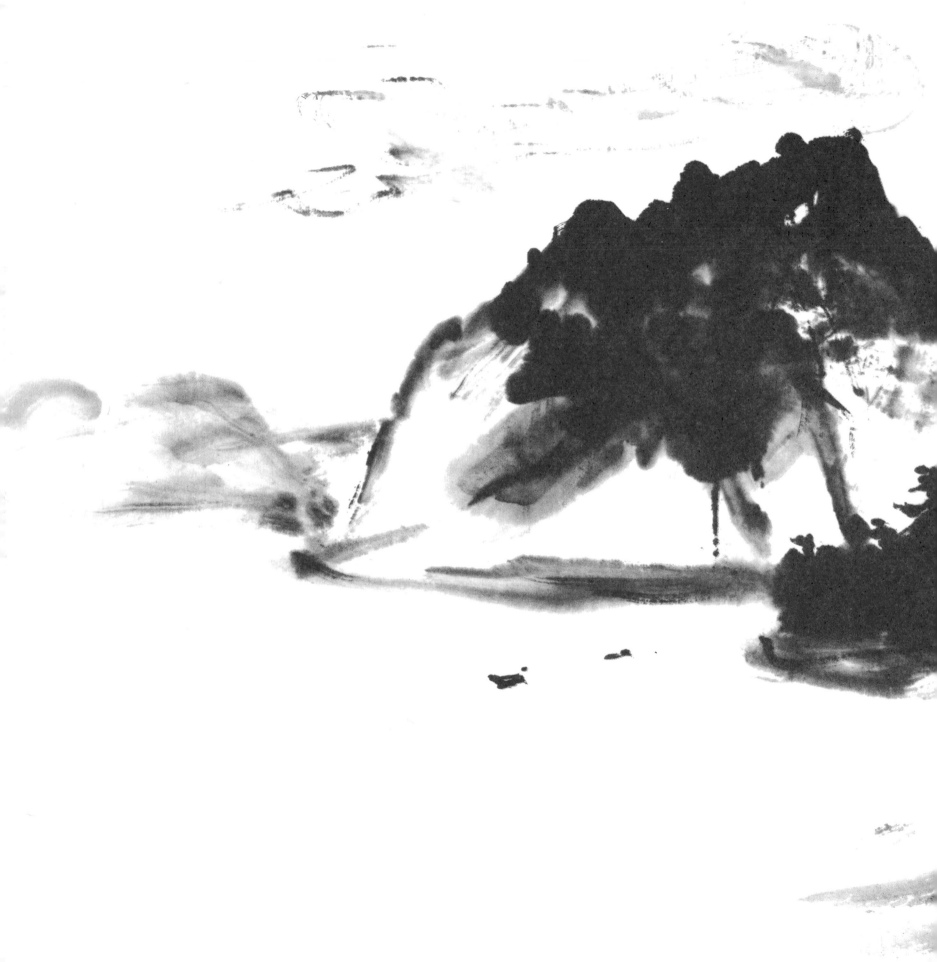

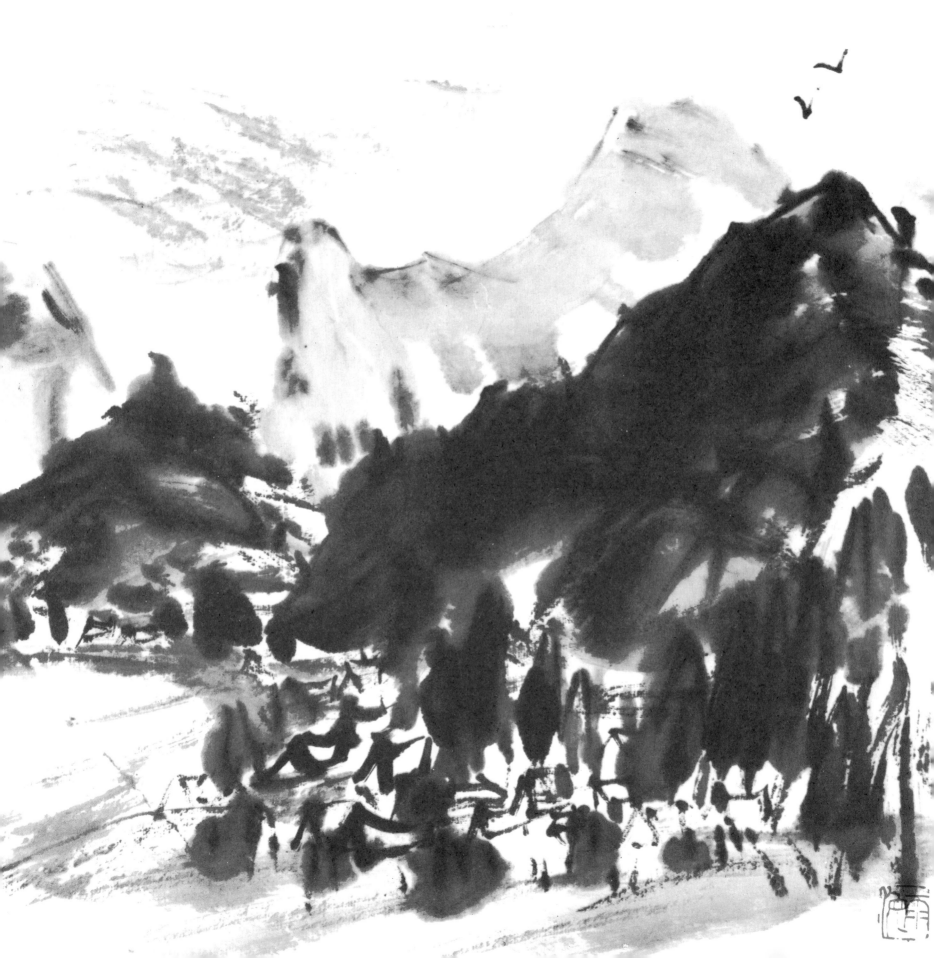

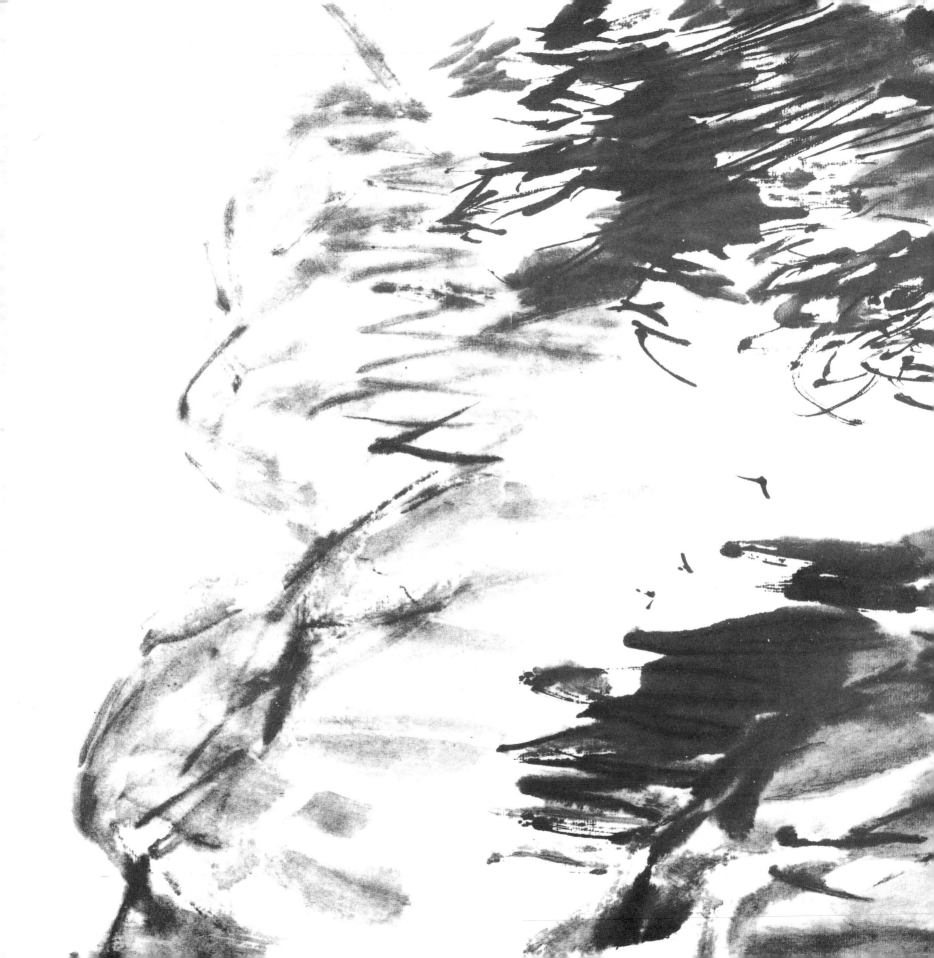

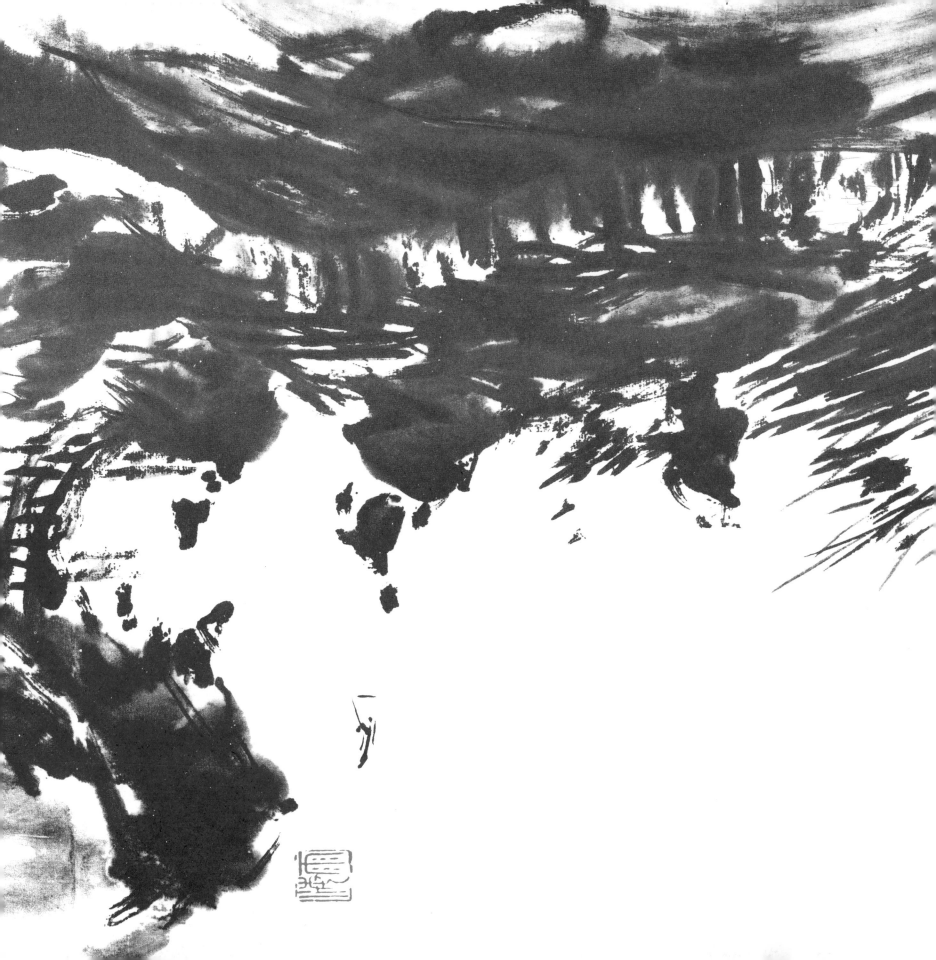

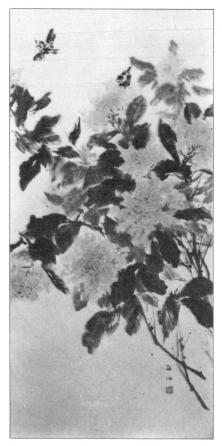

"Hydrangeas and Sparrows." 1958
Sumi on paper. Scale: about 1:11.5

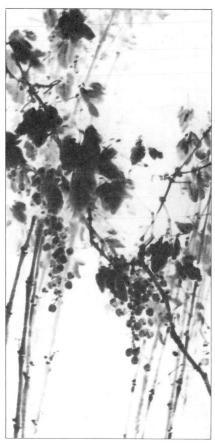

"Grapes." 1958
Sumi on paper. Scale: about 1:11.5

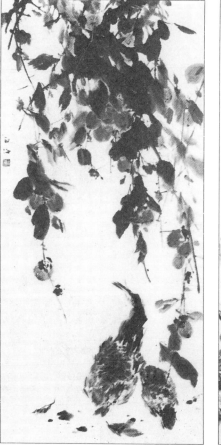

"Persimmons and Chickens." 1958
Sumi on paper. Scale: about 1:11.5

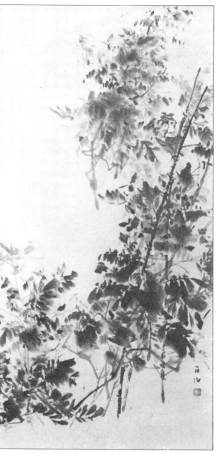

"Sweet Peas." 1958
Sumi on paper. Scale: about 1:11.5

in conclusion

All the preceding illustrations were made for instruction purposes and hence, even when labeled finished paintings, tend toward the less technically complex. On these two pages are presented reproductions of seven of Mr. Uchiyama's fully conceived exhibition pieces; those on the opposite page were included in the Uchiyama exhibit at the Hiratsuka Nippon Gallery, Washington, D.C., in the summer of 1960. Besides setting a goal toward which the sumi-e student should aspire, they reveal the inspired utterance of which sumi-e, with its sparse vocabulary, is capable, and they prove once again that this great and ancient art is still vital and fresh.

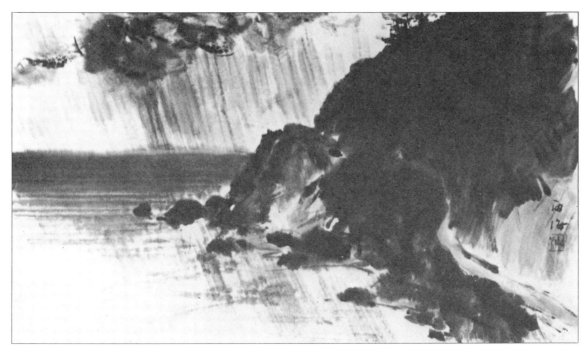

"The Eastern Shores of Izu." 1959
Sumi on paper. Scale: about 1:6.5

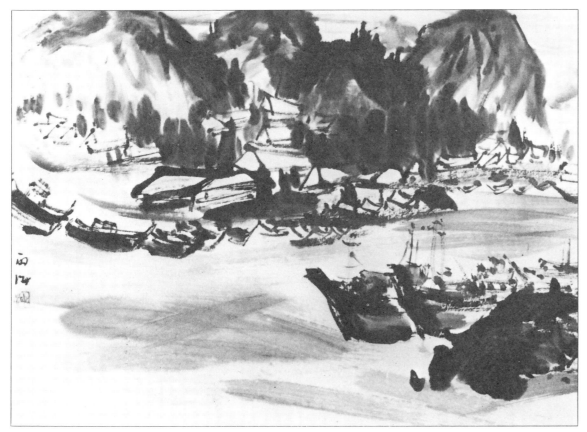

"Shimoda Port." 1959
Sumi on paper. Scale: about 1:6.5

"Sparrows." 1959
Sumi on paper
Scale: about 1:6.5

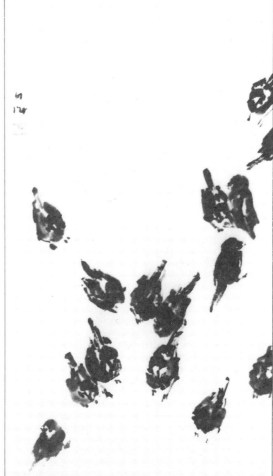

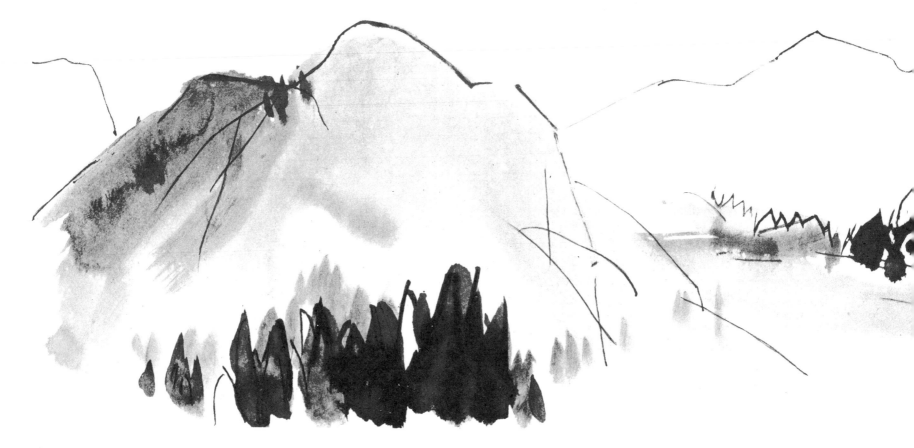

glossary-index

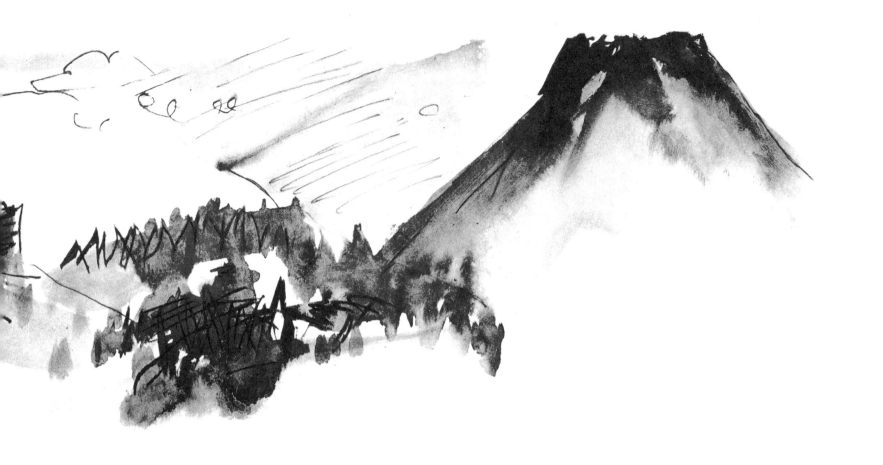

"happiness"